Contents

GEOF

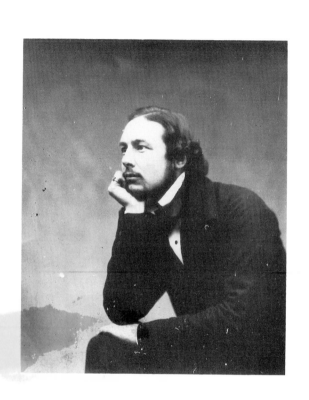

George Price Boyce

CHRISTOPHER NEWALL AND

JUDY EGERTON

THE TATE GALLERY

cover
Streatley Mill at Sunset 1859
(cat.no.24)

frontispiece
George Price Boyce 1862–1897
photograph from original glass
negative by an unknown photographer
National Portrait Gallery

Photographic credits: A. C. Cooper, John Freeman, John Webb

ISBN 0 946590 77 X
Published by order of the Trustees 1987
for the exhibition of 24 June – 16 August 1987
Copyright © 1987 The Tate Gallery All rights reserved
Published by Tate Gallery Publications, Millbank, London SWIP 4RG
Designed by Caroline Johnston
Printed by The Hillingdon Press, Uxbridge, Middlesex

Sponsored by The Dow Chemical Company
in aid of
Queen Elizabeth's Foundation for the Disabled

*Trademark of The Dow Chemical Company

Foreword

This is the first exhibition to be devoted to the work of George Price Boyce. Although his friendship with Rossetti and other Pre-Raphaelite artists is well known through the publication of his Diaries, his own very distinctive work is less familiar. Allen Staley rightly drew attention to Boyce's watercolours in his book *The Pre-Raphaelite Landscape*, 1973; and our exhibition *The Pre-Raphaelites* in 1984 included two works by Boyce. The connection with the Pre-Raphaelites however is only part of Boyce's career. He began as an architectural draughtsman; David Cox encouraged him to take up landscape painting and later he became a friend of Whistler's, living in a house in Chelsea that Philip Webb had built for him. We are glad now to have the opportunity to show his work more fully.

The selection of the exhibition has been made by Christopher Newall and by Judy Egerton, Assistant Keeper in the Tate Gallery's Historic British Collection; the Introduction was written by Mr Newall, and the catalogue compiled by Mrs Egerton. They would like to express their gratitude to all the descendants of Boyce's nieces and nephews who have helped with information and in particular to Mrs Anne Christopherson and Mr Michael Harvey. They are also grateful to the librarians of the British Library, the Library of University College London, the Bodleian Library, Oxford, and to Mr Jeremy Maas, for permission to quote from unpublished manuscripts in their possession.

We are most grateful to all those descendants, collectors and museums whose willingness to lend has made this exhibition possible.

ALAN BOWNESS *Director*

Introduction

The name of George Price Boyce is familiar to many people who are interested in mid-nineteenth-century English painting. Boyce's relative fame derives largely from the diaries which he kept during the years 1851–75, in which he described the circle of friends which gathered around the figure of his close friend the Pre-Raphaelite painter Dante Gabriel Rossetti. Boyce was a gregarious and amiable man who entered with enthusiasm into the semi-bohemianism of artistic life and at the same time he received and interpreted the new ideas about painting which stemmed from the Pre-Raphaelite revolution. Boyce's impressionable character and disinclination to seek the limelight for himself made him a shrewd and revealing commentator about his contemporaries. However a consequence of his modesty was that his own personality and objectives as an artist were obscured. If George Price Boyce is now better known as a friend of artists than as a painter in his own right this imbalance is the result of the legacy of written words that he left behind. His real importance was as a dedicated and intermittently hard-working watercolourist of architectural and landscape subjects, who was committed to the professional life of exhibiting drawings and occasional oils in London's forum of exhibition spaces, and who was much admired by patrons, critics and fellow-artists.

George Price Boyce was the eldest of the five children of George Boyce and Anne Price; he was born in London at Gray's Inn Terrace on the 24th September, 1826. George Boyce senior abandoned a career as a City wine merchant for that of pawnbroking, in which business he seems to have prospered. By 1845 he was the proprietor of two pawnbroking shops, in Theobald's Road and Lisson Grove, and was in a position to maintain his young family at Maida Hill on what were then the north-western outskirts of London in a house which Boyce's future brother-in-law Henry Tanworth Wells was to describe as having 'views over the open fields right away to Harrow'. (H.T. Wells's unpublished notes on the life of G.P. Boyce, Bodleian Library, Oxford: MS.don.e.60 p.79.) George Boyce senior may have had other business or trade interests (in his will he described himself as

a silversmith); it seems that the family gradually distanced themselves from the pawnbroking business which was perhaps not considered respectable. Nonetheless it was probably in this commercial sphere that Boyce's father amassed sufficient wealth to allow his eldest son a relatively independent way of life.

Of Boyce's siblings it seems that he was most attached to his youngest sister Joanna, who was born in 1831; her early success as a painter preceded his own and may have encouraged him to follow the same career. His brother Matthias, who was born in 1829, became a solicitor and was occasionally to give legal advice to Rossetti.

Boyce was sent to school in Chipping Ongar in Essex, and afterwards allowed to study in Paris. In October 1843 he was articled to an architect called Mr Little, with whom he remained until September 1847. In the autumns of 1846 and 1847 he travelled through south-west Germany, the Low Countries and north-west France, studying architecture and making pencil sketches of what he saw. In the latter part of 1847 he joined the firm of architects Wyatt & Brandon as an improver.

Despite his fascination with the structure and ornament of buildings, demonstrated in his early minutely observed studies of architectural form, Boyce did not succeed in his projected career. Wells noted in a diary entry in March 1849: 'George in low spirits as to his prospects – not improving himself at Wyatt & Brandon's'. (H.T. Wells's unpublished notes, Bodleian Library, Oxford: MS.don.e.60 p.79.) In the summer of 1849 Boyce was further discouraged by having various drawings rejected in an architectural competition. However, despite his feeling increasingly despondent, his time was not wasted as he had the opportunity to practise his draughtsmanship. Boyce's nephew-by-marriage Arthur Street described various of his uncle's drawings from these years of apprenticeship: one particularly, 'an inch-scale elevation of a decorated window', 'betrays a lapse from the strict paths of architectural virtue in the loving realism of the random work of the surrounding wall face'. These words might serve to describe architectural subjects painted by Boyce over the following forty years.

All indecision about the future course of Boyce's career was resolved when he met David Cox in August 1849. 'This meeting', according to Boyce's friend and obituarist Frederic George Stephens, 'seems to have led to Boyce's giving up

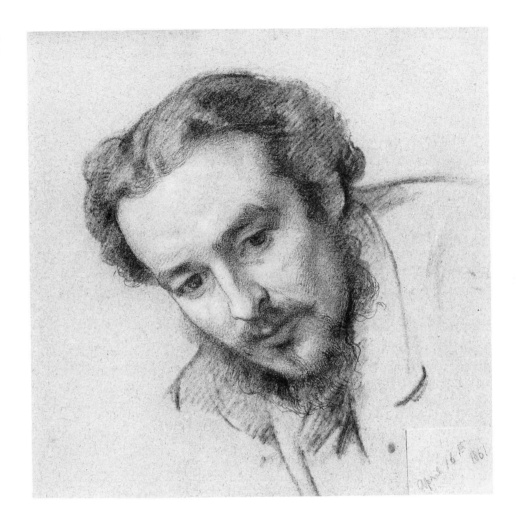

architecture and taking to painting with characteristic single-mindedness and thoroughness.' (*Athenaeum*, 13 Feb., 1897, p.221.) Boyce's first style of landscape painting in watercolour, as seen in drawings such as 'Landscape near Trefriw' (No.10), shows the clear influence of Cox in the generalisation of the masses of the landscape and the rapid calligraphic treatment of the vegetation. In the summer of 1851, from July to October, Boyce was back at Bettws-y-Coed and met

Cox again. He noted that 'While sketching, David Cox came and shook hands with me. He has put up here (the "Royal Oak"). After dinner I made an evening sketch on grey wrapping-up paper. David Cox saw it and approved.' (*Diaries*, p.2.)

Boyce slowly progressed towards a more searching inspection of nature and the forms of landscape, as advocated by John Ruskin in the two first volumes of *Modern Painters* which had appeared in 1843 and 1846. Cox must have recognised something exceptional in his occasional student, for in August 1851 Boyce had cause to write 'Completed drawing from Church, which Mr. Cox said looked like a Pre-Raffaelite drawing.' (*Diaries*, p.3.) Boyce's watercolours 'Castle Rock, Hastings' (No.9) and 'A Road near Bettws-y-Coed' of 1851 (Yale Center for British Art) reveal new artistic preoccupations in their concern for the detail and local colour of the landscape.

At this stage Boyce's idols remained figures from the great generation of romantic painters; in February 1852 he admired the luminosity of Girtin's and Turner's watercolours; in the previous December he had attended the latter's funeral in St. Paul's Cathedral. Nevertheless, since about 1849, Boyce had been in touch with various of the young Pre-Raphaelite painters whose radical ideas were beginning to attract attention throughout the artistic community. Boyce met Thomas Seddon in 1849 and was consequently influenced towards a more minute treatment of landscape subjects. The two painted together in Dinan, Brittany, in the summer of 1853, and later in the same year Boyce painted his watercolour 'Babbacombe Bay, Coast of Devonshire' (No.12). In the painstaking observation of the shapes and distribution of the rocks and pebbles of the beach, and the broken forms and verdure of the more distant headland, enlivened by the warm colours and clarity of light of a sunlit day, this work represents an early exercise in genuine Pre-Raphaelite landscape technique.

It was perhaps Seddon who introduced Boyce to Dante Gabriel Rossetti. Various members of the Pre-Raphaelite circle attended the life classes that Seddon organised at his house in Gray's Inn Road, and it was probably on one of these occasions that Boyce and Rossetti first met. On the other hand, H.T. Wells, when consulted by F.G. Stephens just before Boyce's death, believed that he had brought the two together soon after he had first met Boyce in North Wales in 1849. Whatever the circumstances of their meeting a great affection grew up between Boyce and Rossetti, who were then aged about twenty-seven and twenty-

five respectively. Although their objectives as painters were very different each consulted the other about artistic matters for many years to come.

Rossetti 'detested working out of doors' (Surtees: *Diaries*, p.85, note 25) and was not adept at painting the naturalistic landscape elements which he occasionally sought to include in his figurative pictures. Boyce could occasionally assist him with these details. In April 1856 Rossetti wrote to Boyce: 'Would you very much oblige me by making a tracing of a windmill *forthwith* & sending it [to] me by *return of post*. There are several in that book of yours & I'm introducing one, without the remotest notion of how to draw it.' (Unpublished letter, The Library, University College London: Ogden MS.82 p.6.) Rossetti concluded his letter with the postscript: 'I'm writing to Ruskin for leave to duplicate that sketch.' The windmill to which Rossetti was referring appeared in comparative illustrations of Stanfield's and Turner's approach to drawing a windmill, as plate 19, *The Picturesque of Windmills*, in Volume IV of Ruskin's *Modern Painters*, first issued in March 1856. Another instance of Rossetti's dependence on Boyce as a landscape painter occurred in 1858 when, as Boyce recorded, 'Rossetti called and borrowed 2 sketches of mine on the coast of Babbacombe as a help to background of a delicate little drawing of a loving couple on a sea beach on a windy day he is doing for Miss Herbert'. (*Diaries* p.24.) Thus Boyce's ability to evoke the sensations of light and atmosphere was acknowledged and exploited by Rossetti on this single occasion when he attempted an open air modern life subject in watercolour. Rossetti's 'Writing on the Sand' is now in the British Museum.

That the young Boyce was respected as a landscape painter in the Pre-Raphaelite circle is testified to by the interest that John Ruskin took in him. In April 1854 Ruskin and his father called on Boyce hoping to see the Rossetti drawings in his already expanding collection. Boyce's own landscape water-colours and one of his portrait drawings were also admired and a conversation occurred in which Ruskin expanded on his belief that art should serve the purpose of objective record-making rather than simply evoking picturesque scenery or striking atmospheric effects: Boyce noted that, 'On my expressing my liking for after sunset and twilight effects, he said I must not be led away by them, as . . . they were easier of realisation than sunlight effects.' (*Diaries*, p.13.) Although Boyce was gaining confidence in his own ideas, and had come to value his stylistic independence as a painter, he was nonetheless bowled over by the

inspirational figure of Ruskin, and for a number of years remained within the great man's sway.

In the early months of 1854 Boyce worked in earnest on a view of the interior of Edward the Confessor's Chapel at Westminster Abbey (No.11), a watercolour which he may have hoped Ruskin would commend for its meticulous reconstruction of the gothic architecture. Later in the year he departed for Europe, where in the Alps and Italy he saw places and buildings which Ruskin particularly admired. The journey was an act of homage to Ruskin, with whom Boyce remained in touch, via various *Poste Restante* addresses, at each stage. On the outward journey Boyce travelled 'through Paris, Strasbourg, Bâle and the valley of Ticino to Milan, Brescia, Verona, Padua & Venice, arriving at the last place on the 16th [June].' (Caroline Boyce's unpublished notes on her late husband's life, Bodleian Library, Oxford: MS.don.e.60 p.61.) In Venice he received a letter from Ruskin which opened with an apology for having 'perhaps been partly instrumental in leading you into the expense and trouble of a long journey, when there was quite enough material to employ you delightfully nearer to home.' (V. Surtees: *Diaries*, Appendix, pp.119, 120.) Ruskin proceeded to direct Boyce to work on an exterior view of the Basilica of St Mark's; he wrote: 'I congratulate myself, in the hope of at last seeing a piece of St. Marks done as it ought to be: It answers precisely to your wishes, as expressed in your note, "*near* subject - good architecture - colour - & light & shade".' In a second letter Ruskin recommended a specific view of the basilica's south-west portico, seen from the loggia of the Doge's Palace: 'St. Marks portico comes in somehow so – [sketch] with the top of the broken square capital of the St. Jean d'Acre pillar underneath – & St. Marks place behind most beautifully.' The watercolour that Boyce painted in response (No.13) was his most deliberate and ambitious attempt to satisfy the Ruskinian desire for information about architectural subjects. Boyce has drawn close to the building (which he in fact observed from pavement level rather than the loggia as Ruskin had suggested and as he was later to treat the subject himself – see fig.11), and has allowed its forms to fill and expand beyond the available pictorial space; the veined textures and mottled colours of the marble columns and porphyry cladding are studied with minute attention to detail; and the complex physical structure is revealed in dramatic perspective by the bright sunlight and strong cast of shadows over its surfaces.

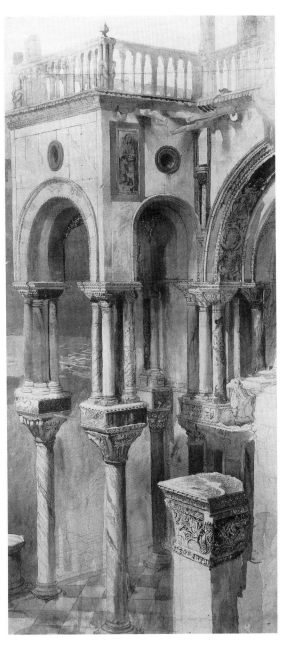

fig.II John Ruskin, *The South Side of the Basilica of St Mark's, Venice, seen from the Loggia of the Doge's Palace* (Private collection)

Boyce was evidently delighted by everything he saw in Venice; in the four months or so that he spent there he produced many remarkable watercolours. If his first object was to record the architectural monuments which he and Ruskin feared were in danger of destruction or insensitive restoration, on other occasions he painted hidden corners of the city and crowded side-canals. Sometimes he ignored Ruskin's admonitions against generalised and crepuscular effects and described the vespertine or nocturnal city in semi-abstract studies in which the form of buildings and ships loom from broadly handled areas of monochromatic tone. Watercolours such as 'Near the Public Gardens, Venice' (No.16) speak of the romantic impression that Venice made on the young artist rather than his dutiful observation of her architecture.

Ruskin may perhaps have been concerned that Boyce might be distracted from his set purpose by resigning himself to the mesmerising beauty of the city. In his first letter he had warned: 'you may be so dazzled by the splendour of effect in Venice as not to estimate justly the value of *Verona*. I should strongly recommend you, after you have done with St. Marks, to quit the Venetian canals, and to make a most careful study of the Porch of the *Duomo* of Verona, which in its Gryphon sculpture, is the finest thing that I know in North Italy – while, of course – the little group of the Scala Monuments is altogether unrivalled *in the world* for sweet colour & light and shade; and in these times there is no knowing how long it may stand.' Boyce spent October and November of 1854 in Verona and made two drawings of the Scala Monuments (Lyman Allyn Museum, New London, Connecticut and No.19). Boyce left Verona on November 14th and travelled 'through Cremona, Pavia, Milan, Como, Lucerne, Dijon, Paris, arriving home December 5th.' (Caroline Boyce's unpublished notes on the life of G.P.Boyce, Bodleian Library, Oxford: MS.don.e.60 p.62.) Four days after his return he attended a lecture Ruskin gave on the general theme 'Decorative Colour as applicable to Architectural and other Purposes'. Boyce was impressed by what Ruskin said and spoke to him afterwards. Ruskin 'immediately asked when he might come and see my drawings, I said in about a fortnight. He said, "Not before? Pray don't go and botch them in the studio." Hoped I was a confirmed Pre-Raphaelite, etc.' (*Diaries*, p.14.) It is not known in detail what Ruskin's reaction was to the work that Boyce had done in 1854; one can only presume that he would have heartily approved of various of the architectural

subjects (in 1858 he was 'a good deal taken with one of the Venice [Verona?] tomb drawings' (*Diaries,* p.20.)) Perhaps Boyce forebore to disconcert the sage by showing him the indulgent and romantic studies in which he evoked the moods of the cities he had visited.

During the second half of the 1850s Boyce led a convivial life in London; many of his friends were painters and he participated in the events and festivities of artistic life. He was on amicable terms with Millais (on one occasion, when dining with the Millaises, he surprised his host by announcing that he had seen Millais's great portrait of Ruskin in the latter's bedroom.) Boyce's friendship with Holman Hunt became strained because of the jealousy that Hunt felt towards those who had been friendly with, or who had painted or drawn, Annie Miller, whom Hunt then sought to marry. In January 1858 Hunt requested and then insistently demanded the portrait drawing of her that Boyce had made in 1854

fig.III George Price Boyce, *Portrait of Annie Miller* (Collection of Edmund J. and Suzanne McCormick)

(McCormick Collection, U.S.A. – fig.III). It seems that Boyce remained irritated by Hunt's high-handedness; the only later diary references to him conjure a figure whom the writer considered pompous and absurd: in 1861 'From an omnibus top saw Holman Hunt with nose high in air' (*Diaries*, p.32) and, much later when the two met at dinner at William Bell Scott's, 'Hunt very prolix and goosy.' (*Diaries*, p.62.)

The pleasant ambience and easy-going manners of the world that Boyce inhabited, and which he shared with his friend Rossetti, are conveyed in the latter's drawing 'Fanny Cornforth and G.P.Boyce in Rossetti's Studio' (No.1) which Virginia Surtees has dated to *circa* 1858. (*Apollo*, XCVII no.132, February, 1973.) Boyce has been unkindly described as 'essentially a libertine, responding to a pretty face or a sexy look but never losing his head or his heart.' (Jan Marsh: *Pre-Raphaelite Sisterhood*, 1985, p.155.) Certainly Rossetti's drawing seems to treat the theme of romantic love between a couple who were not married but nonetheless this recent moral stricture seems an unfair charge on the basis of the snippets of information provided by Boyce's diaries. What is essentially true is that he enjoyed women's company and became involved in various rather delicate tripartite love affairs. Boyce was himself well-liked by the young girls who as models were drawn into the Pre-Raphaelite orbit and in certain instances these friendships proved long-lasting. He was perhaps known for his susceptibility to the attractions of pretty girls. Rossetti gave Boyce a drawing of his which was made to illustrate an Italian song that he had translated; it is hard to resist the idea that Rossetti affectionately identified his friend, who was incidentally fond of boating and a powerful oarsman, with the figure who is restrained from falling overboard when transfixed by a vision of female beauty. Rossetti's 'Boatmen and Siren' (fig.IV) is now in the collection of Manchester City Art Gallery.

Boyce was a sincere and perceptive portraitist; his small-scale and carefully composed half-length portrait watercolours of various young women are amongst the private icons of Pre-Raphaelite painting. The genre of portraiture is re-presented in the present exhibition by portraits of Ellen Smith (No.6 and, with the title 'Nora', No.5) and Alexa Wilding (No.7.) Both girls were occasional models to Rossetti and a certain irritation occurred between the two friends when they found that they were in competition to have one of the girls sit for their drawings or paintings.

fig.IV Dante Gabriel Rossetti,
Boatmen and Siren
(Manchester City Art Gallery)

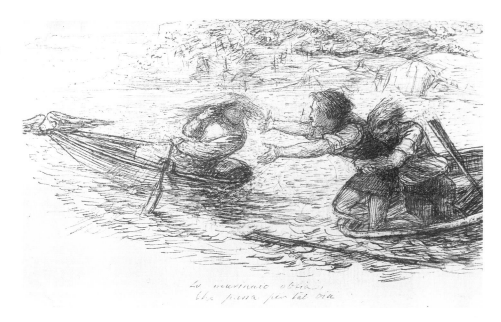

During the four years of its existence, 1858–62, the Hogarth Club was an important private exhibition space and meeting place, where ideas were exchanged and friendships formed, for dozens of painters of the Pre-Raphaelite generation. Boyce was a founder member and many of his wider circle of friends, including Ford Madox Brown, Edward Burne-Jones, Arthur Hughes, Frederic Leighton and John William Inchbold, also belonged. He was also a member of the similarly short-lived Mediaeval Society, which was founded in 1857. Although various of his fellow-members were architects, including Street, Bodley and Burges (with the last of whom Boyce shared lodging in Buckingham Street, Adelphi, until 1862), J.R.Clayton, William Morris, Coventry Patmore and William Bell Scott represented different walks of life. The purpose of the society was to rekindle interest in the arts and architecture of the Middle Ages, as an inspiration to contemporary artists and architects. It perhaps anticipated in its desire to see mediaeval architecture preserved the Society for the Protection of Ancient Buildings, better known as the Anti-Scrape Society, of which Boyce and Philip Webb were to be leading members in the 1870s.

Like many other young landscape painters in the 1850s Boyce found opportunities to exhibit his works hard to come by. Twelve of his paintings were shown at the Royal Academy Summer Exhibitions between 1853 and 1861; the titles of these works, which may have included oil paintings as well as water-colours, indicate the range of his subjects. In 1854 he exhibited two Breton landscapes from the trip to Dinan with Seddon; in 1855 two of Boyce's architectural subjects, 'Edward the Confessor's Chapel, Westminster' (presumably No.11) and 'St. Mark's, Venice – South West Angle' (presumably No.13) were accepted. In 1857 he participated in the Pre-Raphaelite Brotherhood Exhibition in Russell Place, which was organised by Ford Madox Brown. Boyce was irritated by the way in which one of his two exhibits was reframed, but despite this setback he still contemplated lending four drawings to the American Exhibition of British Painting which was being organised in the same year.

Few other exhibition spaces were open to anyone who was not a member of a particular association. Boyce once or twice showed at the Portland Gallery and at the Society of British Artists in Suffolk Street, but it was clear that he should seek election as an associate of the Old Water-Colour Society and thus become eligible to exhibit at the Summer and Winter Exhibitions of the Society at their premises in Pall Mall. From as early as 1854 Boyce had submitted drawings to the Society but he in fact waited ten years before being elected as an associate. In 1864 his friends Fred Walker, Edward Burne-Jones and the Swedish-born painter Egron Lundgren were also enrolled. Burne-Jones's friend Cormell Price sent a joking message to Boyce: 'Hearing you are turned into an old W.C. I cannot forebear writing a line to commiserate with you, which I do with all my heart, though at the same time I cannot understand why you were not so served long ago.' (Unpublished letter, Collection of Jeremy Maas.)

Throughout his career Boyce was an habitual traveller. In 1856 he had returned to the Alpine village of Giornico to work on mountainous landscape subjects and views of the Romanesque parish church of S. Nicolò da Mira. In October 1861, following the death in child-birth of his sister Joanna in July, Boyce set out for Egypt, travelling in company with the topographical artist Frank Dillon and Lundgren. J.L. Roget described their sojourn in North Africa:

These three artists hired a house in Gizeh on the river bank, and there they
lived for a time in Oriental fashion. [Lundgren's] letters describe the native

hospitality they received from a young Egyptian, Iscander Bey, son of the late Solomon Pasha, visits to the Boulay Museum and the Sphinx's head, and an English picnic at the Pyramid of Cheops.' (J.L. Roget: *A History of the 'Old Water-Colour' Society*, 1891, Vol.II, p.405.)

While exploring Cairo and the Nile Valley Boyce remembered his friend Seddon, who had died in Egypt in 1856. Boyce owned Seddon's 'The Great Sphinx at the Pyramids of Giza' (Ashmolean Museum, Oxford) and when he came to paint a similar view, from an angle which gave less of the Sphinx's face but included a glimpse of the green waters of the Nile, (No.34), it was perhaps as a conscious tribute to Seddon.

In February 1862 Lundgren wrote: 'Boyce is gone. He takes with him an interesting number of costumes and curiosities.' By the beginning of April Boyce was back in London, and on the 14th he noted that 'D.G. Rossetti called on me and stayed 3 or 4 hours. . . . Did not like what I had done in the East. Said that all the things that artists brought from the East were always all alike and equally uninteresting.' (*Diaries*, p.34.) At about this time Rossetti wrote more affectionately to Boyce: 'And now, after all this selfishness [talk about his own painting], how about yourself? And what have you done? I shall be truly glad to see you again, as I think you & I are among the most lastingly get-on-ables.' (Unpublished letter, The Library, University College London: Ogden MS.82 p.21.)

In the later 1850s Boyce's subjects, even when architectural elements are indicated by the titles, take on a more countrified air and others were pure landscapes. Boyce was certainly influenced, as were the majority of contemporary landscape painters, by the types of subject recommended in Ruskin's *The Elements of Drawing*, which was published in 1857. Ruskin had shared his fondness for timeworn buildings and landscapes seen in the very process of elemental decay and reconstitution, in passages such as the following:

If you live in a lowland country, you must look for places where the ground is broken to the river's edges, with decayed posts, or roots of trees; or, if by great good luck there should be such things within your reach, for remnants of stone quays or steps, mossy mill-dams, etc.' (Cook and Wedderburn (eds.): *The Works of Ruskin*, Vol.XV, 1904 p.109.)

From the late 1850s Boyce was inclined to go out into the countryside in search of subjects, and to study nature at close range in accordance with the principles of Pre-Raphaelite landscape painting. Buildings are often included in Boyce's later watercolours but are seen as part of a wider setting and are usually merged with the natural elements of the landscape. Boyce contemplated and absorbed the landscape and vernacular architecture of certain specific parts of the countryside; the watercolours that he painted of, for example, Mapledurham and Pangbourne, contain the *génius loci* of those places so that one inspects the scene for clues about the world beyond. The complex details and subsidiary parts of the landscape are always treated with affectionate accuracy. Thus the silhouette of roof-lines and chimneys of his view of 'Mapledurham House' (No.28) corresponds exactly to reality and the gable of the dormer window is still decorated with white oyster shells. Boyce had such a strong feeling for old buildings, whether ancient country houses or decrepit sheds attached to overgrown water-mills, that he would never

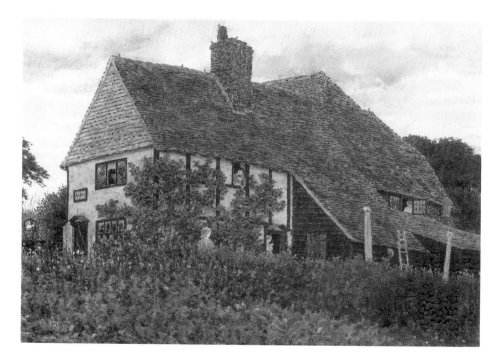

fig.v George Price Boyce,
Champ's Cottage
(Private collection)

change or generalise any of their details. Philip Webb wrote to Boyce on one occasion about a view the latter was painting in Northumberland: 'I shall know more of the place [Stagshaw Bank] when I have seen your drawing, as, happily, one has not to translate your work & ask how the thing looks in reality.' (Unpublished letter, British Library: BM 45354 p.167.) Boyce's watercolours are so rigorously observed that one has complete faith in their authenticity. The eye is intrigued both by what is revealed and what is concealed; one explores a world about which one has a plethora of information, and yet which exists only as a product of the artist's creative vision.

Boyce immersed himself in the places where he chose to work. He loved the River Thames and the countryside of the Thames Valley, and he explored its reaches on foot and by rowing boat. Each summer from 1859 and through most of the 1860s he stayed to paint in the villages of Pangbourne, Mapledurham, Whitchurch and Streatley. George Dunlop Leslie described Boyce's circumstances during these periods of retreat:

> At Pangbourne I met my friend G.P. Boyce, the water-colour artist, who was lodging at Champ's picturesque little cottage on the edge of the weir pool [fig.v]; the rooms were very old and small, and it pleased Mr. Boyce's taste to hang amongst the humble cottage pictures one or two precious little works by D. Rossetti. He had brought with him also some of his favourite old blue tea-cups and plates. He painted two very fine works whilst I was at Whitchurch: one of Champ's cottage itself and the weir pool with a twilight effect, and the other of a large old barn half-way up the hill at Whitchurch [see No.38]; there were a lot of black Berkshire pigs snoozling in the straw in the fore-ground.' (G.D. Leslie: *Our River*, 1888, pp.10–11.)

Boyce shared his enthusiasm for the river with friends and fellow painters; he wrote, for example, to F.G. Stephens from Wallingford in about 1867: 'Do you know this reach of the Thames? It is very beautiful & characteristic. The more's the pity – & misery – that I find myself in anything but good working order.' (Unpublished letter, Bodleian Library, Oxford: MS.don.e.60 p.20.) Boyce's architectural and pure landscape subjects of the Thames Valley are among his most characterful and individual works. When Boyce was an old man his friend Webb wrote to him: 'I went to see your *old* drawings on Thursday, before Anti-

scrape meeting. It was like being in the country with you 20 – or so – years ago, and looking at beautiful parts of England.' (Unpublished letter, British Library: BM 45354 p.283.) Boyce's watercolours offer an intimate account of the undisturbed countryside.

Other parts of the country which Boyce knew well from his peripatetic search for subjects were Surrey and Sussex, where he painted the heathlands of Abinger and the quaint houses and inns of Chiddingfold and surrounding villages. With various of his contemporaries, including Alfred Hunt and Fred Walker, he was encouraged by certain North Country industralists, most notably Lowthian Bell who lived at Washington in County Durham, to describe the sublime beauties of a landscape in the process of industrialisation. Boyce painted views of the Tyne Quays at Newcastle (No.40), swarming with commercial activity and the site of stupendous feats of engineering. His watercolour 'From the Windmill Hills, Gateshead-on-Tyne' (No.42) shows a distant view of the smoky city of Newcastle from Gateshead on the south bank of the Tyne.

Boyce's fascination with ancient architecture led him throughout England in search of interesting and preserved buildings, from the Saxon church at Bradford-on-Avon, which he inspected on behalf of the Anti-Scrape Society, (Philip Webb asked him for a 'memento or two' of the great tithe barn while he was there (see No.57)), to the parish church of Ashbourne in Derbyshire, seen in the course of an exploration of Derbyshire and Staffordshire during which he was so long away that Webb wrote: 'I thought for certain that you had drowned yourself in Churnet, or the Dove, or Manyfold'. (Unpublished letter, British Library: BM 45354 p.136.) In the 1870s Boyce frequently visited Ludlow, where he drew the ancient black and white houses (Nos.53 and 54) and described the picturesque appearance of the old town. As he grew older Boyce came to prefer more remote and severe landscapes. In 1873 Webb wrote to him: 'The country you are in now, is altogether too unstirring & "smug" for your wants.' (Unpublished letter, British Library: BM 45354 p.53.) Amongst the most characteristic of Boyce's later subjects were the peel towers of the Northumbrian and Cumbrian borders and the ancient defences of hill-towns in the Auvergne and Burgundy.

Despite all his wanderings Boyce lived principally in London, and loved the old corners and monuments of the capital. He painted the old innyards which had

once served coach-travellers arriving in or departing from London. 'The Black Lion Inn' and 'Oxford Arms' (Nos.32 and 47) were amongst his subjects. In 1889 he wrote to F.G. Stephens: 'Another of the few left of the anct. interesting arctl. relics of old London – Staple Inn – gone to the dogs. Damn the sordid money-grabbing vandals.' (Unpublished letter, Bodleian Library, Oxford: MS.don.e.60 p.46.) Boyce's London views are marked by his constant interest in the shapes and colours of buildings and their variety and irregularities of construction. His fondness for the back end of a subject, seen across an untidy and neglected foreground or glimpsed over a churchyard wall (as in 'Backs of some old Houses in Soho' (No.45)), provides an authentic vision of nineteenth-century London.

Amongst the painters who are thought of as Pre-Raphaelite landscapists Boyce was relatively slow to attempt the minute and brightly coloured works which his friends Inchbold and Brett were painting in the mid-1850s. However Boyce's watercolours from *circa* 1859 onwards, including in the present exhibition his two Thameside subjects 'Streatley Mill' (No.24) and 'The Mill on the Thames at Mapledurham' (No.27), are thoroughgoing exercises in Pre-Raphaelite method. In each the structure of the building is carefully studied; the materials of the clap-boarding and plaster and the roofs of tile or stone-slating are observed with infinite patience. In 'Streatley Mill' a creeper is seen engulfing the front of the mill-house; at 'Mapledurham' thick patches of green moss have overgrown the roofs. One of Boyce's favourite devices was to paint screens of trees across his compositions, either to create a curtain through which subsidiary views may be glimpsed, as at the left-hand of 'Mapledurham' where the parish church is veiled by the green of poplar leaves. Often Boyce allowed trees to stand like sentinels across the breadth of a view, and thus forced the eye to look through and beyond the compartments and interstices of stems and branches. Boyce's landscapes are constructed of dense and overlapping elements, apparently never arranged to make the subject easier to paint or more legible to the eye. Trees are seen entwined together, because they were aligned in perspective, and the roof-lines of houses combine visually with clumps of trees. Boyce was not concerned with arranging or prettifying the landscape, but observing it with the utmost thoroughness. In this search for information he was a complete Pre-Raphaelite.

On the other hand, objective though Boyce's view of the physical world may have been, the very reality of his drawings depends on ceaseless activity and

minor incident, the normality of which reassures the spectator that the artist's presence is not intrusive. Figures appear in doorways or wave to one another from upstairs windows; cats gaze peaceably at the passing scene and birds of different species cluster on the roofs and in the leafy backgrounds. Of all Pre-Raphaelite landscape painters Boyce gives the greatest sense of the everyday life of the countryside; the clamour of birdsong, the murmur of water in the mill-pond and the rustle of poplar leaves even on a still summer's day, speaking to the modern spectator as if they had never been interrupted.

Boyce was seen by his friends and contemporaries as a remarkable and quite out of the ordinary painter. Exhibition reviewers occasionally sought to explain the strange quality with which he invested the landscape and commented on his avoidance of the conventionally picturesque or obvious view. In 1866 the *Art Journal* stated: 'Mr. Boyce is singular in the choice of his subjects, inasmuch as he loves to plant his sketching stool just where there is no subject. Yet does he manage to make out of the most unpromising of materials a picture which for the most part is clever and satisfactory'. (*Art Journal*, 1866, pp.174-5.) In its review of the following year's Old Water-Colour Society Summer Exhibition the *Art Journal* stated:

> G.P. Boyce has the advantage of being eccentric, and his style will hardly become commonplace, save in the repetitions of his imitators. He displays pictures which, as usual, please by their peculiarities. [Among them in 1867 No.46.] Sometimes he is sombre, often lustrous, always harmonious even in his contrasts. That he affects subjects which an ordinary artist would condemn as unpaintable, is rather in his favour.' (*Art Journal*, 1867, p.147.)

Boyce's friend F.G. Stephens was the principal critic for the *Athenaeum* in the 1870s and '80s; in his reviews of contemporary exhibitions, and in his famous series of articles about collections of modern paintings published between 1873-84, he often gave enthusiastic accounts of Boyce's work.

During the later 1860s Boyce was part of the circle of friends associated with the dawning Aesthetic Movement. As early as 1860 he described meeting at the National Gallery 'a gallicized Yankee, Whistler by name, who was very amusing, and with whom I walked part of the way home'. (*Diaries*, p.29.) A friendship and exchange of ideas ensued between the two artists. Since his visit to Venice in

1854 Boyce had been interested in the effects of twilight on the city landscape; in London he occasionally painted the moonlit Thames from the rooms in Buckingham Street which he occupied until 1862. 'Night Sketch of the Thames near Hungerford Bridge' (No.31) is an example of Boyce's evocation of the nocturnal cityscape of the early 1860s. Whistler and Boyce perhaps discussed the possibilities of this type of subject; Whistler had long been interested in the topography of the river by day, and on one occasion in 1863, after Boyce's move to Chatham Place, he 'began an etching from one of my windows looking up the river'. (*Diaries*, p.37.) Boyce's semi-abstract and poignantly beautiful studies of the city by night certainly anticipate by several years Whistler's own *nocturnes*, the first of which was painted after his visit to Valparaiso in 1866, and were perhaps an inspiration to the American artist.

Many of Boyce's friends, including Rossetti, had gravitated during the 1860s towards Chelsea. On one occasion Boyce described in his diary an evening spent amongst this community of artists: 'at Swinburne's, taking with me as a contribution to his housekeeping 2 old blue and white wedgwood dishes and a very fine Chinese plate or dish. Present: D.G. Rossetti, Whistler, Val Prinsep, Ned Jones and Sandys. Whistler gave humorous vent to a lot of comic stories. Walked away with Jones and Rossetti. Chat about Ruskin'. (*Diaries*, p.35.) Rossetti was keen that Boyce should move westwards so that they might be neighbours; in 1862 he suggested that they should share Tudor House in Cheyne Walk, writing: 'if you liked we might probably house together supposing you thought there was space which suited you. Would you like to accompany us on Thursday & look. Of course I do not wish to bias you in the least one way or the other, but you are the only additional man of my intimates with whom I would be housed, so that I would ask you. If not I shall have no anxiety in entering upon the house alone with William [Michael Rossetti] & Swinburne'. (Unpublished letter, The Library, University College London: Ogden MS.82 p.18.) Boyce refused the offer and Rossetti briefly considered Ruskin as a co-tenant, but 'not without misgivings quite as much on his account as my own'. (Unpublished letter The Library, University College London: Ogden MS.82 p.20.) In 1864 Rossetti wrote confidentially from Tudor House, Cheyne Walk to Boyce 'to say I have just seen the house next door to this, & I think it would suit you very well. Whistler is after some other place, & *entre nous* I had rather have you for a

neighbour than that dearest but most excitable of good fellows'. (Unpublished letter, The Library, University College London: Ogden MS.82 p.30.) In the event Boyce remained at Chatham Place until 1868 when he suffered a severe typhus fever attack. In that year he commissioned Philip Webb to design and build a house in Glebe Place, Chelsea. West House, as it was called, was completed in 1871 and stands as one of Webb's masterpieces of domestic architecture (fig.VI). Webb was jokingly alarmed to work for someone who was himself trained as an architect; when the house was finished he wrote to Boyce: 'I will send you the original, signed sheet of plans with pleasure, for you to keep - and if you ever return [to] architecture you may copy it, put one of your own windows in it, à la Pecksniff, and spoil it & build it 20 times over without admonition from me'. (Unpublished letter, British Library: BM 45354 p.34.) Boyce lived happily at West House for the rest of his life, surrounded by his collection of pictures by contemporary artists and paintings by old masters, and from 1875, with his French wife Augustine Caroline.

Boyce continued to paint architectural and landscape subjects until the beginning of the 1890s. He gradually moved towards a looser technique and a more subdued range of colours and tones, but still succeeded in expressing the character of places with great individuality. If he was conscious of declining skills this was despite the encouragement of friends and admirers, and the evidence of various of his late watercolours, such as the series of views of Vézelay done in *circa* 1879 (e.g. No.59). In 1878 he was finally made a full member of the Old Water-Colour Society; the society's slowness to allow him full membership, which became a matter of embarrassed comment amongst those who knew him, can only be explained by a feeling that his financial independence made his professional status equivocal. By 1878 Boyce was past caring about the honour that the society paid to him. He wrote to F.G. Stephens 'Confessedly there was a time when I should [have] felt the honour & the compliment of the election more & when it might have been of more help . . . [now] I could only desire that my eyesight & bodily strength & endurance promised my being able to do as good or better work for myself, for those who care for my work & for the Society than hitherto.' (Unpublished letter, Bodleian Library, Oxford: MS.don.e.60 p.37.)

In the 1870s Boyce's friendship with Rossetti began to slacken. At the start of the decade Rossetti reassured Boyce with the words: 'You don't *really* think, I

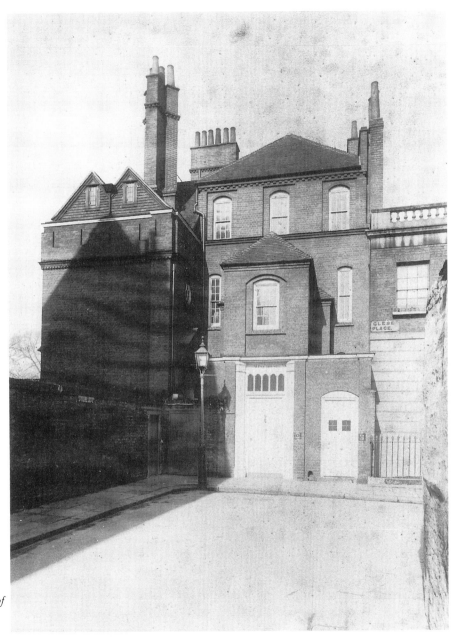

fig.vi *The street entrance and exterior of West House*, photograph (Collection of Mrs Anne E. Christopherson)

know, that you are out of mind with me, but the fact is just as I said before - you make long absences and one is apt to forget at times your being available'. (Unpublished letter, Collection of Jeremy Maas.) In 1878 Boyce wrote to William Allingham: 'D.G.R. I have not seen now for a long while, indeed not since his illness last autumn - neither here, nor in his house nor elsewhere. It seems strange & unnatural & I regret it, but there appears no prospect of a change'. *Diaries*, Introduction, p.ix.) In 1882 Boyce attended Rossetti's funeral at Birchington and in the following year helped organise the Burlington Fine Arts Club Memorial Exhibition.

Boyce ceased to exhibit at the Old Water-Colour Society in 1891 and in 1893 was listed among the 'Hon. Retired Members'. Boyce suffered a stroke early in 1896 and became paralysed during the following winter. He died at West House on the 9th February 1897. His funeral was at St Luke's, Sydney Street, after which his body was placed in the Boyce family mausoleum at Kensal Green Cemetery. He was mourned by friends and painters alike and his death was noticed by obituarists in newspapers and art magazines.

Boyce's reputation as a painter and member of the Pre-Raphaelite circle has never been entirely eclipsed. At the sale of the contents of his studio and of his collection, which was held by Christie's in July 1897, members of the Boyce family competed with a new generation of drawings collectors for possession of some of his finest works. In 1898 a number of his drawings were exhibited as part of the Old Water-Colour Society's Winter Exhibition and in the following year Boyce's nephew-by-marriage, Arthur Street, wrote a short account of Boyce's life for *The Architectural Review*. In 1923 an exhibition of *Paintings and Drawings of the 1860 Period* was held at the Tate Gallery; Boyce's importance in the minds of those looking back on the mid-Victorian age from the perspective of the inter-war period is demonstrated by his having been represented by sixty-two works, which were hung beside paintings by his sister Joanna and friends including Charles Keene, Burne-Jones and Rossetti. A momentous event occurred in 1941 when Boyce's niece Mrs Arthur Street allowed an abbreviated version of her uncle's diaries to be published by the Old Water-Colour Society's Club in their Nineteenth Annual Volume. This text is the only record of Boyce's manuscript because the original was destroyed, along with paintings by both Boyce and

Rossetti, in the Streets' house in Somerset Place, Bath, during one of the Baedeker raids of April 1942.

If Boyce has never been quite forgotten, in recent years he has been celebrated as a most interesting Victorian artist whose works, although small in scale and most intimate in their means of expression, are sincere and delicately beautiful. Allen Staley devoted a chapter in his seminal book *The Pre-Raphaelite Landscape* (1973) to Boyce, and concluded that, even if his name 'appears in the modern literature on Pre-Raphaelitism . . . because of his diary, he was more than just a friend of Rossetti'. More recently Virginia Surtees has interpreted and annotated Boyce's diaries and thus made them accessible to a modern audience. Those who have previously known Boyce's name as the friend of Rossetti and as an intriguing figure on the Pre-Raphaelite periphery may now consider him as an artist in his own right.

CHRISTOPHER NEWALL

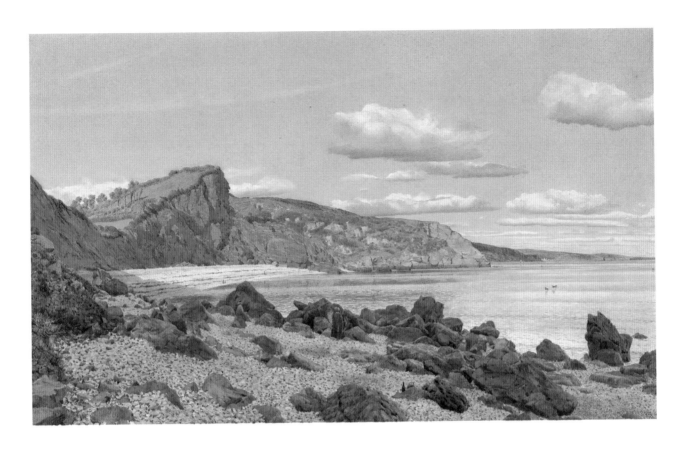

1 **Babbacombe Bay, Devon** 1853 (cat.no.12)

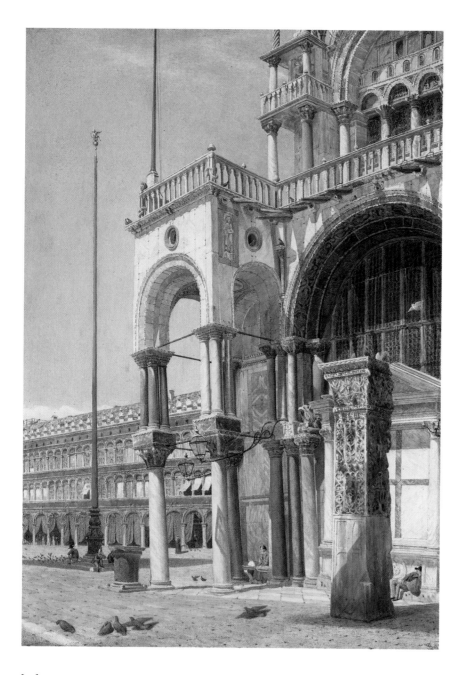

2 **St Mark's, Venice,
South-West Angle**
1854 (cat.no.13)

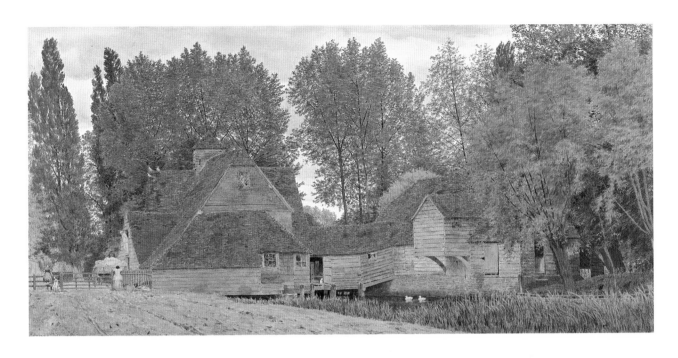

3 **The Mill on the Thames at Mapledurham**
1860 (cat.no.27)

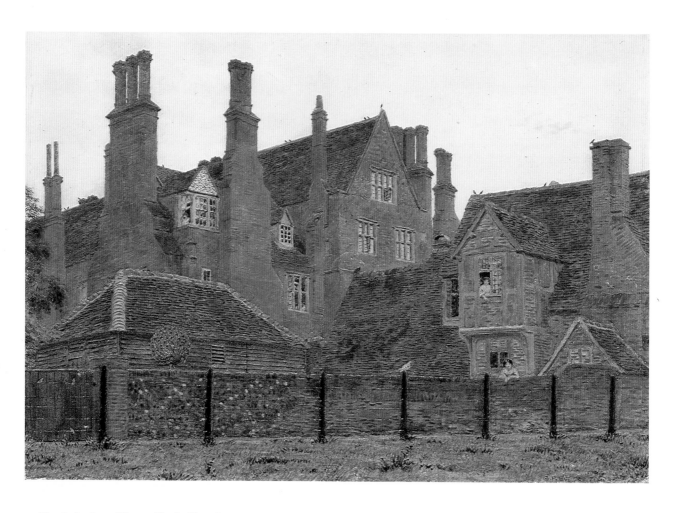

4 **Mapledurham House: Early Morning**
1860 (cat.no.28)

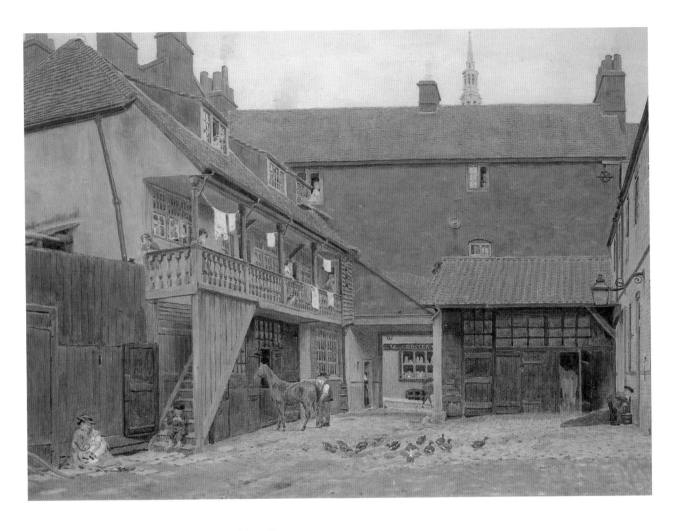

5 **The Yard of the Black Lion Inn, Whitefriars Street,
City of London** ? *c.*1860 (cat.no.32)

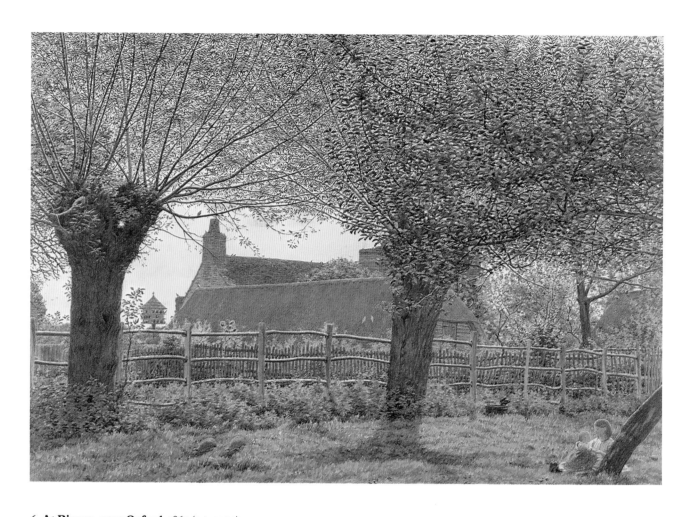

6 **At Binsey, near Oxford** 1862 (cat.no.35)

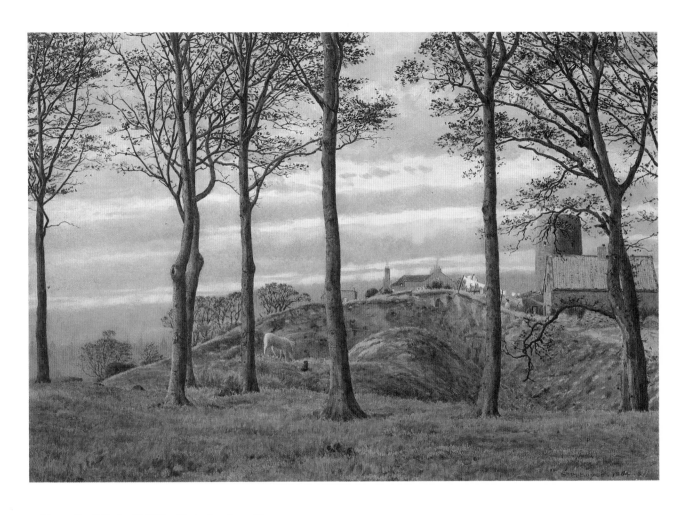

7 **From the Windmill Hills, Gateshead-on-Tyne**
1864–5 (cat.no.42)

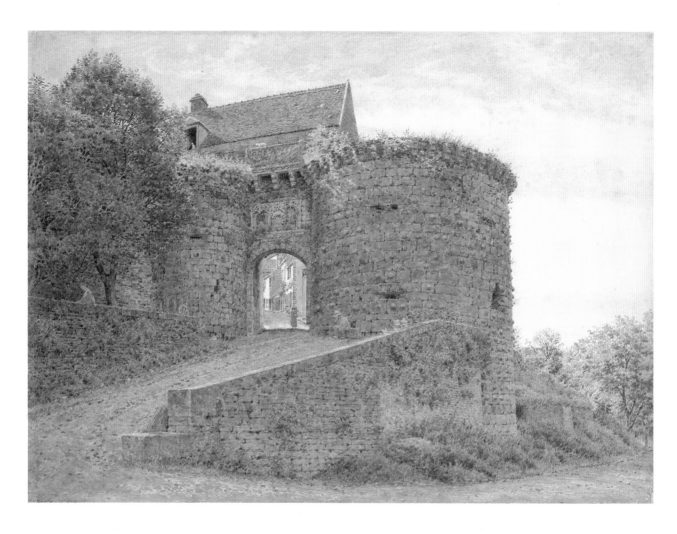

8 **Port Neuve at Vézelay, Burgundy, from
 Outside the Walls** 1878–9 (cat.no.59)

Catalogue

Notes

The compilers would like to acknowledge their debt to Virginia Surtees's impeccably annotated edition of *The Diaries of George Price Boyce*, 1980, shortly referred to below as *Diaries*. Quotations from Allen Staley, *The Pre-Raphaelite Landscape*, are with his kind permission.

'Watercolour' is given as the medium for most of Boyce's works; though he sometimes adds touches of bodycolour (gouache), and often makes considerable use of scraping out with the end of a brush or with a palette knife, watercolour, often of considerable intensity, remains his chief medium.

Measurements are given in inches followed by millimetres, height before width.

Abbreviations

Diaries	ed. Virginia Surtees, *The Diaries of George Price Boyce*, Norwich, 1980
EXH:	exhibited
Grigson	Geoffrey Grigson, *Britain Observed*, 1975
LIT:	literature
OWCS 1941	Arthur E. Street, 'George Price Boyce, with extracts from Boyce's Diaries 1851–1875', *Old Water-Colour Society's Nineteenth Annual Volume*, 1941, pp.1–71
OWCS/RWS	Old Water-Colour Society; originally the Society of Painters in Water-Colours, called the Old Water-Colour Society following the foundation of a New Society in 1831, and called the Royal Water-Colour Society from 1881
PROV:	provenance
RA	Royal Academy, Royal Academician
REPR:	reproduced
Staley 1973	Allen Staley, *The Pre-Raphaelite Landscape*, Oxford, 1973
Surtees	Virginia Surtees, *The Paintings and Drawings of Dante Gabriel Rossetti*, 2 vols. Oxford, 1971
Tate Gallery 1923	*Loan Exhibition of Paintings and Drawings of the 1860 Period*, Tate Gallery, 27 April–29 July 1923

DANTE GABRIEL ROSSETTI
1828-1882

**1 Fanny Cornforth and
G.P.Boyce in Rossetti's
Studio** c.1858
Pen and ink $8\frac{3}{4} \times 12\frac{1}{2}$ (222 × 318);
verso, various sketches

PROV: ? Ruth Herbert; . . .; Gordon
Bottomley, by whom bequeathed
to Carlisle Museum and Art
Gallery 1949

LIT: Virginia Surtees, 'A Conversation
Piece at Blackfriars', *Apollo*,
XLVII, February 1973, pp.146-7,
fig.1; *Diaries*, 1980, pl.8

Carlisle Museum and Art Gallery

This drawing is fully discussed by
Virginia Surtees in her *Apollo* article,
1973. The setting is Rossetti's studio at
14 Chatham Place, Blackfriars. Rossetti
depicts his model Fanny Cornforth lean-
ing affectionately over Boyce's shoulder
as he paints (? in oils) at an easel. Boyce
first records meeting Fanny Cornforth on
15 December 1858, when he and Rossetti
'went off at dusk . . . to see Fanny . . . In-
teresting face and jolly hair and engaging
disposition'. Fanny Cornforth figures
abundantly in PRB literature. For other
images of her, see Jan Marsh, *The Pre-
Raphaelite Sisterhood*, 1985, pls.21-30.

Boyce himself was to occupy the
Chatham Place rooms from 1862, after
Rossetti moved to Chelsea, until 1868.

HENRY TANWORTH WELLS
1828-1903

**2 Study for 'Conversation
Piece'** 1861
Oil on board $8\frac{1}{4} \times 10\frac{1}{2}$ (210 × 274)

PROV: Boyce family, by descent to the
present owner

Madeline Goad

Boyce records on 31 January 1861 'Sat to
Henry Wells [his brother-in-law] for a
couple of hours', probably for this pic-
ture. The composition shows, seated at
the table from left to right, G.P.Boyce,
his sister Joanna (who died later in 1861)
and her husband H.T.Wells, with J.R.
Clayton in the background. The finished
picture was probably the work entitled
'Portraits - including a portrait of the late
Mrs H.T.Wells' exhibited by Wells at the
RA in 1862 (4). It was reproduced in
OWCS, 1941, pl.1, when in the collection
of Mrs Arthur Street, but was destroyed,
with Boyce's diaries, in an air-raid; it was
reproduced from a photograph in *Diaries*,
1980, pl.2.

HENRY TANWORTH WELLS

**3 Study of G.P. Boyce
Sketching** c.1860
Pen and ink $6\frac{7}{8} \times 4\frac{5}{8}$ (175 × 117)
Inscribed 'sketched by H.T.
Wells RA | from GPB'

PROV: Boyce family, by descent to the
present owner

G.R.Street

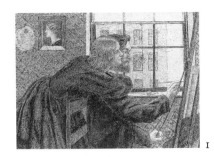

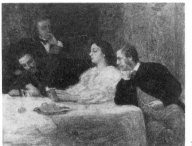

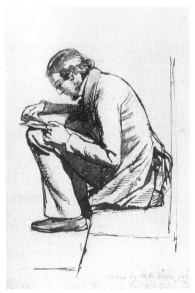

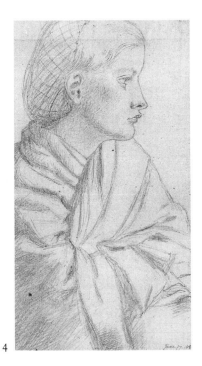

4

The remaining works are all by G.P. Boyce; after a small group of portraits, the landscapes are arranged in chronological order.

4 **Portrait Study of Annie Miller** 1860
Pencil $5\frac{1}{2} \times 3\frac{1}{4}$ (140 × 83)
PROV: . . .; J.Michael Moffatt
EXH: *Stunners: Paintings and Drawings by Pre-Raphaelites and Others*, Maas Gallery 1974 (38)

Jeremy Maas

Annie Miller was William Holman Hunt's model in the 1850s; in the Tate Gallery she can be seen as the newly repentant woman in Hunt's 'The Awakening Conscience'. As Boyce records (*Diaries,* 1980, p.20), Hunt hoped to make a marriageable woman out of her. Another pencil portrait of her by Boyce which Hunt determinedly secured for himself is discussed and reproduced by Susan P.Casteras, *The Edmund J. and Suzanne McCormick Collection*, 1984, pp.22-3; it is reproduced here as fig.iii and in Jan Marsh, *The Pre-Raphaelite Sisterhood*, 1985, pl.16 (and see pls.15, 17–20 for other images of her). A pen and ink study of her by Rossetti is reproduced in Andrea Rose, *Pre-Raphaelite Portraits*, 1981, p.103.

5 **Portrait of Ellen Smith ('Nora')** 1866
Watercolour $8\frac{1}{8} \times 6$ (207 × 152)
Inscribed 'G.P.Boyce 1866' lower left and 'Nora' lower right
PROV: Presumably purchased from Boyce by P. & D.Colnaghi, Scott & Co., for stock; in their sale of stock owing to the death of one of their partners, Christie's 16 March 1867 (888) £12 bt Baxendale; . . .; Julian Hartnoll
EXH: OWCS Summer 1866 (167)
LIT: *Athenaeum*, 19 May 1866, p.677; *Diaries*, p.46

Pre-Raphaelite Inc.

Ellen Smith, a laundry-maid whom Rossetti spotted in the street and persuaded to sit for him, first appears in Boyce's diaries on 13 April 1863; that day he visited Rossetti, who 'made me a present of a lovely study in pencil of the head of the girl who is now sitting to him'. That drawing, inscribed 'D.G.R. to his friend G.P.B. 1863', is in the collection of Birmingham Museum and Art Gallery (repr. Andrea Rose, *Pre-Raphaelite Portraits*, 1981, p.104). Ellen Smith's features can be seen in the Tate as the sitter for one of the four bridesmaids in Rossetti's 'The Beloved' (or 'The Bride': pl.263 in Surtees 1971, *q.v.* for her other sittings to Rossetti). Boyce acquired three more pencil studies by Rossetti of Ellen Smith.

5

6 **Portrait of Ellen Smith** 1867
Watercolour $9\frac{1}{4} \times 6\frac{3}{4}$ (235 × 172)
Inscribed 'G.P.Boyce 1867'
lower left

PROV: . . .; the Property of a Lady, sold
Sotheby's 24 July 1963 (249 as
'the Artist's Wife') bt Agnew,
from whom bt by the present
owner 1965

EXH: *The Pre-Raphaelites as Painters
and Draughtsmen*, Fermoy Art
Gallery, King's Lynn 1971 (3 as
'The Artist's Wife')

Private collection

7 **Portrait of Alexa Wilding**
1867-8
Watercolour $9\frac{1}{4} \times 8\frac{1}{8}$ (235 × 207)
Inscribed 'G.P.Boyce | 1867-8'
lower left and 'Alexa' on back of
frame

PROV: (? this one) purchased by
'Green's man' (Joseph Green,
frame-maker) from Manchester
Institute exhibition; Boyce
family, by descent to the present
owner

EXH: OWCS Summer 1868 (265);
Manchester Institute 1868

LIT: *Diaries*, 1980, pp.49, 108 n.3

Dr Margaret Jackson

Alexa Wilding was another of Rossetti's
models; she sat regularly to him from
July 1865, and was paid a retaining fee by
Rossetti so that she would not sit to
anyone else. A chalk drawing of her by
Rossetti is reproduced by Andrea Rose,
Pre-Raphaelite Portraits, 1981, p.109.
Boyce swapped his drawing 'Backs of
some Old Houses in Soho' (No.46) for
one of Rossetti's drawings of her (*Diaries*,
1980, pp.44, 46) and acquired others.

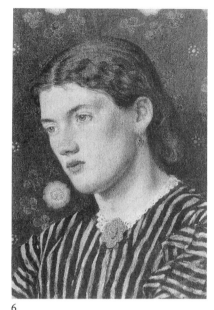

6

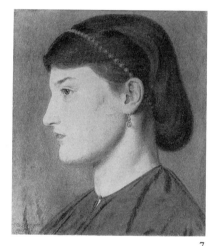

7

8 **A Girl's Portrait** *c.*1868
Watercolour $9\frac{1}{2} \times 7$ (242 × 178)
Inscribed 'A Girl's Portrait | by
George P.Boyce RWS' in Mrs
Boyce's hand on label on back of
frame

PROV: Boyce family, by descent to the
present owner

Private collection

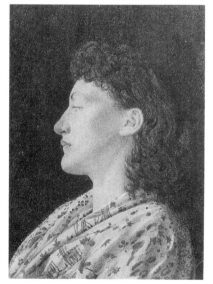

8

9

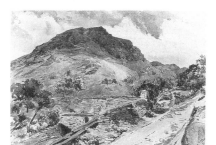

10

9 The Castle Rock, Hastings

1850

Watercolour 10 × 6⅞ (253 × 175),
paper enlarged at lower edge
Inscribed 'GPB' in monogram
lower left and on the verso 'The
Castle Rock – Hastings | from
my bedroom window when laid
up | G P Boyce July 1850'

PROV: . . .; bequeathed by the Rev.
E.C.Dewick to the Williamson
Art Gallery 1958

*Williamson Art Gallery and
Museum, Wirral Borough Council,
Department of Leisure Services*

'The first serious piece of landscape
study that George did was the face of
the sandstone Castle Rock of Hastings.'
(H.T. Wells's unpublished notes on the
life of G.P. Boyce, Bodleian Library,
Oxford: MS.don.e.60 p.85.)

10 Landscape near Trefriw, North Wales ?1851

Watercolour 9⅛ × 13¼ (233 × 335)
Inscribed 'near Trefriw' lower
right, 'G.P.Boyce' across lower
right corner and 'Llyn Crafnant -
Aug 27 [. . .]' in faint pencil lower
left

PROV: . . .; bequeathed by Percy Charles
Mordan to Astley Cheetham Art
Gallery through the National
Art-Collections Fund 1952

*Astley Cheetham Art Gallery,
Tameside Metropolitan Borough*

Probably made on Boyce's visit to North
Wales in August – September 1851, when
he met and received encouragement from
David Cox, whose influence pervades

this and most of Boyce's Welsh subjects.
This can hardly be the drawing which
Boyce refers to as 'Llyn Crafnant' and
which he made in 1856, adding 'a red
flush of flame on the horizon', which
made William Burges (to whom Boyce
gave the drawing in 1858) teasingly persist
in calling 'the 7th Hell, as it reminds him
of Dante's Inferno' (*Diaries*, p.21).

11 The East End of Edward the Confessor's Chapel and Tomb, As They Now Stand

1852-73

Watercolour 20⅜ × 14⅜ (520 × 365)
Inscribed 'G.P.Boyce 1852-73'
lower right, and on the verso
'Drawing made in Edward the
Confessor's Chapel | West-
minster Abbey in 1852 - &
worked upon | again (in the
abbey) & spiral column added | &
figure removed in August 1873
G.P.Boyce'

PROV: Boyce sale 1897 (114) £82.6.0 bt
Charles Fairfax Murray on
behalf of Agnew from whom
purchased by the Victoria and
Albert Museum 1898

EXH: RA 1853 (1112); ? OWCS Winter
1877-8 (110)

LIT: *Diaries*, 1980, pp.11,13; *Connois-
seur*, XCIX, May 1937 (Coronation
Number) repr. p.245, in colour,
captioned 'At the Heart of the
Empire: The Shrine and Chapel
of Edward the Confessor . . .'

*Trustees of the Victoria and Albert
Museum*

Note the phrase 'As They Now Stand' in
Boyce's title; he faithfully observes such

[45]

details as the crumbling masonry and worn ornamentation of the Shrine (since his day repaired, repainted and railed).

In a letter to Boyce of 9 April 1894, Philip Webb wrote 'I do not remember having seen the Edward Confessor's Westminster before - it is a perfect piece of work, and ought to be in the National Collection - and I hope - eventually - it will get to be there' (unpublished letter, British Library: BM 45354 p.283).

Boyce exhibited another drawing of Edward the Confessor's Chapel and Tomb at the RA in 1855; that may have been the work exhibited at the OWCS in 1877-8, and which the *Art Journal* noted was the property of John Wheeldon Barnes of Durham. It is not clear which of the two Philip Webb saw and admired in 1894.

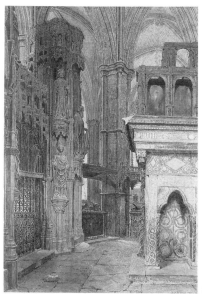

11

COLOUR PLATE I

12 **Babbacombe Bay, Devon**
1853
Watercolour $13 \times 21\frac{1}{2}$ (330×546)
Inscribed 'GPBoyce 1853' (initials in monogram) lower right

PROV: ? Boyce sale 1897 (110) £16.16.0; . . .; bequeathed by Percy Charles Mordan to Astley Cheetham Art Gallery through the National Art-Collections Fund 1952

EXH: ? American Exhibition of British Art, 1857-8 (no catalogue)

LIT: *Diaries*, 1980, pp.11,18,24,85 n.25

Astley Cheetham Art Gallery, Tameside Metropolitan Borough

This is a finished drawing, probably worked up from sketches made on the spot. On 21 June 1858 Boyce recorded

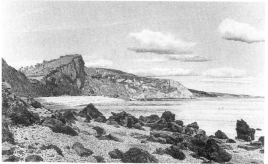

12

that 'Rossetti called and borrowed 2 sketches of mine on the coast of Babbacombe as a help to background of a delicate little drawing of a loving couple on a sea beach on a windy day'. Rossetti's finished watercolour, entitled 'Writing on the Sand' and dated 1858, is in the collection of the British Museum (Surtees 1971, no.111, pl.165); it shows no direct borrowing from this watercolour.

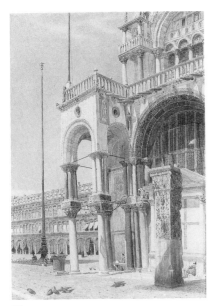

13

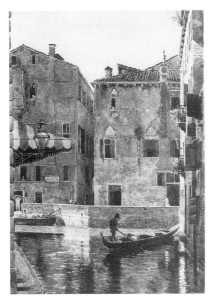

14

COLOUR PLATE 2

13 **St Mark's, Venice,
South-West Angle** 1854
Watercolour 21½ × 15 (546 × 382)
Inscribed 'GPBoyce '54' lower
right (initials in monogram)

PROV: Boyce sale 1897 (III) £18.18.0 bt
H.R.Boyce; thence by family
descent to the present owner

EXH: RA 1855 (1191); ?Pre-Raphaelite
Exhibition, Russell Place 1857
(3 as 'At Venice'); ? American
Exhibition of British Art, 1857-8
(no catalogue)

LIT: Staley 1973, pp.107-8; *Diaries*,
p.18, Appendix pp.119-20

James Hutchings

Ruskin wrote to Boyce on 14 June 1854
expressing 'the hope of at last seeing a
piece of St. Marks done as it ought to be
. . . It answers precisely to your wishes,
as expressed in your note, "*near* subject -
good architecture - colour - & light and
shade"'. In a second letter to Boyce of
28 June 1854, Ruskin wrote 'I am very
glad to hear you like St. Marks, inside &
out, but I believe on the whole, the out-
side is the finer study – the inside is too
Rembrandtesque – too much dependent
on flashing of gold out of gloom – which
is always effective – but comparatively
vulgar – and for the rest – exhausted in
idea by many painters before now, while
the white pure, veined marble, & dark
porphyries of the exterior afford genuine
colour of the highest quality'.

14 **Venice: Looking towards the
Corner of the Fenice Theatre**
1854
Watercolour 13 × 9 (330 × 229)
Inscribed 'GPB 1854' lower right
(initials in monogram)

PROV: John Wheeldon Barnes, Durham,
sold Christie's 7 April 1894 (52)
11 gns bt Charles Fairfax Murray
? on behalf of G.P.Boyce; Boyce
sale 1897 (115)£18.7.6 by Charles
Fairfax Murray ? on behalf of
Boyce family; by family descent
to the present owner

Private collection

15

15 **Venice: An Arcade, with a
Flower-Seller** 1854
Watercolour 10½ × 15⅝ (266 × 372)

PROV: Boyce family, by descent to the
present owner

EXH: Royal Society of British Artists
1856 (807 as 'Arcade, Venice')
£3.3.0

Mrs Florence Hutchings

16 Venice: Near the Public Gardens 1854
Watercolour $7\frac{1}{2} \times 10\frac{3}{4}$ (190 × 273)
Inscribed 'GPB 54' across lower left corner (initials in monogram) and 'Near the public gardens, Venice G.P.Boyce Sept! 1854' on the verso
PROV: ...; Abbott & Holder, from whom purchased by the present owner
LIT: Staley 1973, p.108, pl.54
Private collection

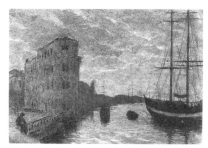
16

Staley instances this as an illustration of his point that 'A number of the Venetian views are remarkably broad and atmospheric . . . On coarse paper, like that often used by Cox, and in a murky, almost monochromatic palette, they show that Boyce still retained his liking for twilight despite Ruskin's advice'.

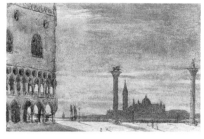
17

17 Venice: San Giorgio Maggiore from the Piazzetta – Moonlight Study 1854
Watercolour $7\frac{3}{8} \times 11$ (187 × 280)
Inscribed 'GPB' in monogram in red, lower left, 'Aug 9th' in pencil above it and 'San Giorgio Maggiore from the Piazzetta, Venice - Aug. 54' on mount at right below drawing
PROV: Boyce family, by descent to the present owner
EXH: OWCS Winter 1868-9 (331)
LIT: *Athenaeum*, 28 November 1868, p.721
Private collection

The Winter exhibitions of the OWCS began as exhibitions of 'studies and sketches', though later Boyce and others sent

in more finished works. The *Athenaeum's* art critic (F.G. Stephens from 1860, ? and throughout the period in which Boyce exhibited) of the 1868-9 exhibition considered that 'For solemnity of effect and breadth of colour, "St. Giorgio Maggiore, Venice" – the towers and domes of the city – have no superior here. Small as it is, this shows the work of an artist and the feeling of a poet'.

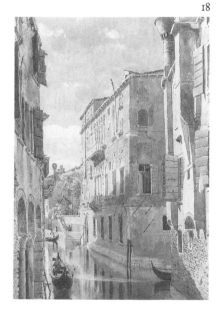
18

18 Venice: Canal Scene 1854
Watercolour $14\frac{3}{4} \times 10\frac{1}{2}$ (375 × 267)
Inscribed 'GPBoyce 1854' lower right (initials in monogram)
PROV: Given by Boyce to his mother, and thence by family descent to the present owner
Michael Harvey

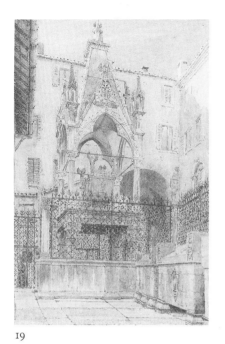

19

19 The Tomb of Mastino II della Scala, Verona 1854

Watercolour $15\frac{1}{2} \times 10\frac{5}{8}$ (394 × 270), paper enlarged at lower edge
Inscribed 'GPB 1854' lower right (initials in monogram), 'G.P.Boyce – Nov. 1854' lower left hand and as title on back of frame

PROV: Purchased at the OWCS exhibition by Professor D.Oliver; Winifred Oliver, by 1923; sold Sotheby's, Pulborough *c.*1979, bt Jeremy Maas, from whom purchased by the present owner

EXH: OWCS Winter 1872-3 (42), priced £28; Tate Gallery 1923 (311)

LIT: *Athenaeum*, 30 November 1872, p.704; *Diaries*, 1980, pp.55, 119

Christopher Newall

Ruskin's letter of 14 June 1854 to Boyce in Venice (see No.13) urged him to go to Verona: '. . . the little group of the Scala Monuments is altogether unrivalled *in the world* for sweet colour & light & shade; and in these times there is no knowing how long it may stand. Venice will retain some of her canal effects for twenty years yet, but the Scala monuments may be destroyed in a fortnight – as far as their effect goes – by any change in the houses round them'.

The *Athenaeum*'s reviewer of the OWCS exhibition 1872-3 described Boyce's drawings as 'a beautiful study in colour and tone, grey and sad, yet brilliant . . . The execution is loyal and delicate, elaborate, yet without signs of labour'.

20 Outside the Church of San Nicolò da Mira, Giornico, Switzerland 1856

Watercolour $14\frac{1}{2} \times 19\frac{1}{4}$ (368 × 488)
Inscribed 'San Nicolo an ancient Lombard Church. Painted on the spot by George Boyce 1856 at Giornico in the valley of Ticino Switzerland' on label on back of frame

PROV: Boyce family, by descent to the present owner

LIT: *Diaries*, 1980, p.77 n.2

Madeline Goad

21 Interior of San Nicolò da Mira at Giornico 1856

Watercolour $17\frac{5}{8} \times 18\frac{1}{8}$ (448 × 462), paper enlarged on all sides

PROV: Purchased by Charles Grainger for 18 guineas before the OWCS exhibition; Mrs Herbert Boyce by 1923, and thence by descent to the present owner

EXH: OWCS Summer 1874 (32); Tate Gallery 1923 (294).

Lewis Hutchings

20

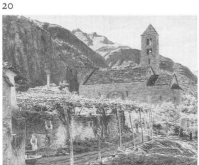

21

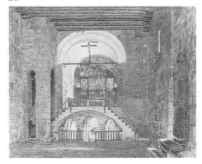

22 Girl by a Beech Tree in a Landscape 1857
Oil on millboard 11¾ × 18⅞ (298 × 480)
Inscribed 'G.P.Boyce. '57' lower left

PROV: Given by Boyce to Frederick Warren, by descent to Mrs Cyprian Warren, on whose behalf sold by the Reid Gallery, Guildford, Christie's 14 July 1972 (7, repr.) bt Mrs Robert Frank, from whom bt by the Tate Gallery 1972

EXH: ? RA 1858 (216 as 'At a Farmhouse in Surrey'); *The Pre-Raphaelites*, Tate Gallery 1984 (91, repr.)

Trustees of the Tate Gallery

This is the only signed and securely attributable painting in oils by Boyce at present known. As one might expect from an artist who is primarily a watercolourist, it is very thinly painted, with the ground visible in the foreground. Boyce's two exhibits at the RA in 1858, 'At a Farmhouse in Surrey' and 'Heath Side – Surrey – an Autumn Study' were evidently both oils. 'At a Farmhouse in Surrey' (216) hung close to Frith's 'The Derby Day' (218); in his *Academy Notes*, 1858, Ruskin pronounced it to be 'Full of truth and sweet feeling. How pleasant it is, after looking long at Frith's picture, to see how happy a little girl may be who hasn't gone to the Derby!' Ruskin's comment could well describe this work, especially as it suggests that the little girl's figure is a prominent one, as it is here but rarely elsewhere in Boyce's work, but Boyce's RA title 'At a Farmhouse in Surrey' hardly seems to fit it.

23 On the West Lynn, North Devon 1858
Watercolour 10¾ × 15¼ (275 × 388)
Inscribed 'G.P.Boyce. '58' lower right of centre and as title on label on back of frame

PROV: Boyce sale 1897 (103) £5.5.0. bt Mrs Charrington, and by descent to the present owner

Private collection

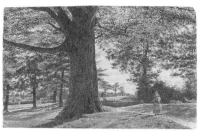

22

COVER ILLUSTRATION
24 Streatley Mill at Sunset 1859
Watercolour 15⅝ × 20⅛ (397 × 515)
Inscribed as title and dated 1859 on label on back of frame

PROV: Boyce sale 1897 (100) £107.2.0 bt Charles Fairfax Murray, presumably on behalf of Mrs G.P.Boyce, by whom offered as a bequest to the Tate Gallery 1930 but declined by its Trustees; by descent in the Boyce family to the present owner

EXH: Tate Gallery 1923 (133)

LIT: Staley 1973, p.109

Private collection

Staley notes that the pair of figures reclining in the foreground are reminiscent of those in Ford Madox Brown's 'An English Autumn Afternoon', painted 1852–4.

This fetched the top price for Boyce's own work in his sale of 1897. It does not appear to have been exhibited in his lifetime. The mill has not survived.

23

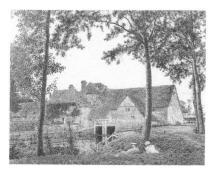

24

25

25 Meadow Orchard at Streatley, Berkshire 1859
Watercolour $7\frac{1}{2} \times 10\frac{7}{8}$ (190 × 276)
Typewritten label on back of frame, probably transcribed from Boyce's inscription on the verso, 'Meadow Orchard at Streatley, Berkshire, painted in the beginning of May 1859'
PROV: Boyce family, by descent to the present owner

Angela Goad

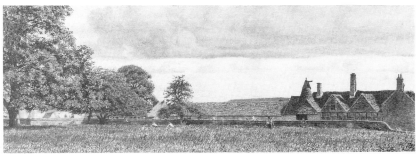

26

26 Farm Buildings near Streatley, with a Meadow and Mowers ? 1859
Watercolour $5\frac{1}{8} \times 16\frac{1}{4}$ (130 × 414)
PROV: Purchased from Boyce for 16 guineas by Major Gillum (d.1910); presented by his widow to the British Museum 1915
LIT: *Diaries*, 1980, pp.29, 90 n.8, repr. pl.4

Trustees of the British Museum

Boyce recorded on 27 February 1860 that Major Gillum paid him 16 guineas 'for the drawing done at Streatley of the long-grass meadow and mowers'.

27 The Mill on the Thames at Mapledurham 1860
Watercolour $10\frac{3}{4} \times 22\frac{3}{4}$ (273 × 568)
Inscribed 'G.P.Boyce . July 1860' lower left and on the verso in pencil 'Mill at Mapledurham Oxfordshire | Boyce – July 1860 – forenoon'
PROV: . . .; Mrs Robert Frank, from whom purchased (Fairhaven Fund) by the Fitzwilliam Museum 1971
EXH: *The Fairhaven Fund. The First Quarter Century*, Fitzwilliam Museum, Cambridge 1976 (11); *Town, Country, Shore and Sea*, Queensland Art Gallery and Australian tour 1982–3, organised by the Fitzwilliam Museum, (87, pl.46)
LIT: Staley 1973, p.109, pl.55a and col.pl.8a; James Harding, *The*

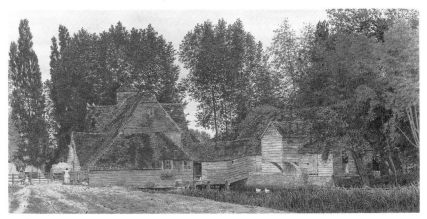

27

Pre-Raphaelites, 1977, p.40; *Diaries*, pl.6
The Syndics of the Fitzwilliam Museum, Cambridge

There is a small pencil study of this subject in a sketchbook in the collection of Jeremy Maas. Surprisingly, the finished work does not appear to have been exhibited in Boyce's lifetime.

Staley cites this as a good example of the 'distinct Pre-Raphaelite character' of Boyce's work in the late 1850s and early 1860s, and adds: 'Like most of Boyce's works from this period it shows scenery on the Thames between Reading and Oxford. The subject is a picturesque rustic building, which is delineated in minute detail. The colours, especially the greens of the foliage, are quite unlike those of Boyce's watercolours of the early 1850s. The effect is one of rural domesticity, rather than natural grandeur. The space is strictly limited by the buildings and trees running across the picture, and it is populated by minutely drawn genre figures, ducks and domestic animals'.

The water-mill survives in part, in working order, and is open to the public.

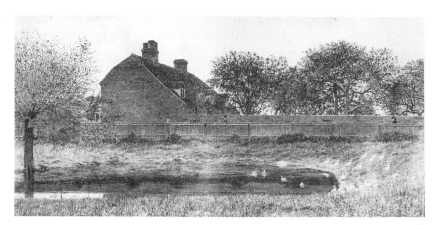

30

COLOUR PLATE 4

28 **Mapledurham House: Early Morning** 1860
Watercolour $7\frac{7}{8} \times 11\frac{1}{16}$ (197 × 281)
Inscribed 'G.P.Boyce.7.60' lower right and on the verso 'G.P.Boyce Mapledurham House, Oxon July 1860 . early morning'
PROV: . . .; Julian Hartnoll, from whom purchased by the present owner
Richard Green

29 **The Orchard at Mapledurham House** 1860
Watercolour $7\frac{1}{2} \times 11$ (190 × 280)
Inscribed 'G.P.Boyce . May 1860' lower left of centre and on the verso 'Orchard & Church Mapledurham | G.P.Boyce in May 1860 | Sunset about 7 pm'
PROV: Purchased from Boyce by William Debenham 1861; . . .; bt by the present owner in an antique shop
LIT: *Diaries*, 1980, p.33
Private collection

29

28

Boyce recorded on 8 April 1861 'Took a lot of my drawings to Henry Wells' studio in Stratford Place. Sold 4 . . . Mapledurham with pigs in foreground to Wm. Debenham 10 gns. ...'. As well as the black Berkshire pigs in the foreground, this view includes a glimpse of Mapledurham Church behind trees in the background.

30 At Sonning Eye, Oxfordshire
1860
Watercolour 10⅝ × 22 (270 × 559)
Inscribed 'G.P.Boyce Aug. 1860'
lower centre and as title on label
on back of frame
PROV: Boyce sale 1897 (118) £40.19.0,
buyer's name not recorded;
Mrs G.P.Boyce, thence by family
descent to the present owner
EXH: Tate Gallery 1923 (265)
G.R.Street

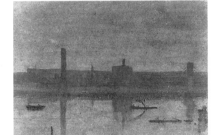

31

**31 Night Sketch of the Thames
near Hungerford Bridge**
?c.1860–2
Watercolour 8¾ × 13¼ (222 × 337)
Inscribed on original mount (now
in the Tate Gallery Archive)
'Southern Bank of the Thames
between Hungerford and
Waterloo Bridges' lower right,
and on its verso 'From my studio
window 15 Buckingham St.
Adelphi | GPBoyce' lower centre
(initials in monogram) and 'Exh^d
at Old W. Colr. Gallery – winter
of 1866' at top
PROV: William Morris; his daughter
May Morris, by whom
bequeathed to the Tate Gallery
1939
EXH: OWCS Winter 1866–7 (364 as
'Rough Night-Sketch of the
Thames near Hungerford
Bridge')
LIT: Staley 1973 p.110, pl.57a; Grigson
1975, pl.101; *Diaries*, pl.5
Trustees of the Tate Gallery

Boyce moved to 15 Buckingham Street (a
short street running from the Strand to-

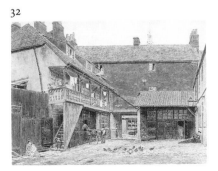

32

wards the Thames) by 1856; he described
his lodgings there as 'two rooms on the
3rd floor overlooking the river near the
foot of Hungerford Bridge' (*Diaries* 1980,
p.79 n.14). He was to move again in 1862
to Rossetti's old rooms in Chatham Place,
Blackfriars, again overlooking the
Thames. Since he noted on the mount of
this watercolour that the view was 'from
my studio window 15 Buckingham Street',
it must have been painted between 1856
and 1862, though not exhibited until
1866. The dating is significant, since it
suggests that Boyce's sketches of the
Thames by night anticipated his friend
Whistler's nocturnes, the first of which
date from 1866. Probably this 'rough
night-sketch of the Thames' was made not
long before Boyce moved from Bucking-
ham St. at the end of 1862. He continued
to make sketches of the river from
Chatham Place studio; on 3 June 1863 he
noted 'Made a study of moonlight effect
on river from my balcony' (*Diaries*, 1980,
p.38). On 5 February 1864 he recorded
'W.[Whistler] has begun 2 pictures on the
Thames, very good indeed' (*Diaries*, 1980,
p.39).

COLOUR PLATE 5
**32 The Yard of the Black Lion
Inn, Whitefriars Street, City
of London** ?c.1860
Watercolour 11½ × 16 (292 × 406)
PROV: Boyce sale 1897 (105) £27.6.0 bt
Street; Ethel Oliver by 1923;
. . .; Gooden & Fox, from whom
purchased by the present owner
c.1970
EXH: Tate Gallery 1923 (272)
Private collection

33 The Edge of the Great Desert, near Gizeh 1861
Watercolour 4⅝ × 8⅝ (118 × 220)
Inscribed 'The Edge of the Great Desert | as it abuts upon the Valley, of | the Nile near the Sphynx & | Pyramids of Gizeh Dec.ʳ 1861 | George P. Boyce' on label on back of frame

PROV: Boyce sale 1897 (81) £16.10.0 bt Charles Fairfax Murray presumably on behalf of the Boyce family, and thence by descent to the present owner
EXH: OWCS Winter 1869–70 (365)
Private collection

33

34 The Great Sphinx of Gizeh 1862
Watercolour 8¾ × 10⅛ (222 × 257)
Inscribed 'G.P.Boyce Janr 1862' lower right and 'The Great Sphynx near the Pyramids of Gizeh | watercolour study made | on the spot in January 1862' on label on back of frame

PROV: ? Boyce sale 1897 (80) £7.9.0 bt Mrs Charrington; by family descent to the present owner
EXH: OWCS Winter 1869–70 (365)
LIT: *Athenaeum*, 4 December 1869, p.742
G.R.Street

William Holman Hunt and Thomas Seddon had both painted watercolours of the Sphinx in 1854 (Staley 1973, pls. 50a, 50b); Seddon's version was in Boyce's collection.

Boyce noted on 14 April 1862 that Rossetti 'Did not like what I had done in the East. Said that all the things that artists brought from the East were always all alike and equally uninteresting' (*Diaries*, p.34).

COLOUR PLATE 6

35 At Binsey, near Oxford 1862
Watercolour 12½ × 21⅛ (317 × 537)
Inscribed 'G.P.Boyce Sep.ʳ 1862' lower right

PROV: Purchased from Boyce by Stewart Hodgson in 1863 for £42; . . .; Colnaghi's, from whom bt by the Cecil Higgins Art Gallery 1958
EXH: OWCS Summer 1864 (106)
LIT: Staley 1973, p.109, pl.55b; Grigson 1975, p.138, pl.99
Trustees of the Cecil Higgins Art Gallery, Bedford

Staley instances this as a very good example of 'the sense of intimacy' which Boyce gives his subjects by restricting the space he allows them. 'A mother and child are seated in the foreground; two guinea-hens scavenge in the grass before them; and a rustic fence and farm buildings close off the view. The foliage of a pair of trees fills the upper half of the composition, forming a screen of delicately drawn leaves across the surface of the picture. There are, of course, birds in the branches'.

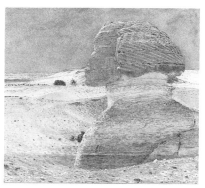
34

35

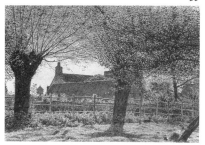

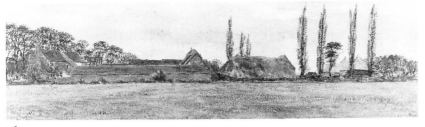

36

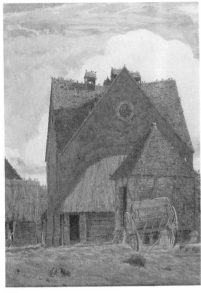

37

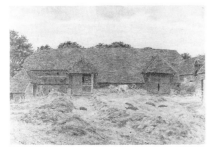

38

36 Tull's Farm, Southridge, near Streatley 1863
Watercolour $3\frac{15}{16} \times 14\frac{1}{4}$ (100 × 336)
Inscribed 'G.P.Boyce Nov. 4. 63'
lower left and 'Tull's Farm |
Southridge | Boyce – Nov. 4. '63 |
foreground field greener' on
verso

PROV: . . .; bequeathed by F.F.Madan
to the Ashmolean Museum 1962

*The Visitors of the Ashmolean
Museum*

**37 Dovecote at South Stoke,
Oxfordshire** 1863
Watercolour $15\frac{1}{2} \times 11$ (394 × 280)
Inscribed 'Dovecote at South
Stoke, Oxon GPBoyce Sept.
1863' on the verso twice (initials
in monogram)

PROV: Boyce sale 1897 (98 as 'Pigeon
House, South Stoke' £12.12.0, bt
Boussod; . . .; Mrs Charlotte
Frank, from whom bt by the
present owners 1972

Mr and Mrs Allen Staley

38 Old Barn at Whitchurch 1863
Watercolour $8\frac{1}{8} \times 11\frac{1}{2}$ (205 × 287)
Inscribed 'G.P.Boyce – Aug.63'
lower left

PROV: . . .; presented by Miss Virtue-
Tebbs to the Ashmolean
Museum 1944

EXH: OWCS Winter 1864–5 (435 as
'Old Barn at Whitchurch, Oxon.
Sketch for larger drawing')

LIT: *Athenaeum*, 3 December 1864,
p.751; 27 April 1872 p.532;
G.D.Leslie, *Our River*, 1888,
pp.10–11; Staley 1973 pp.109,
110, pl.56a

*The Visitors of the Ashmolean
Museum*

Boyce exhibited a version of this subject,
without the horse and cart, at the OWCS
in the summer of 1864 (299); that version
was reproduced from the collection of
Sir Maurice Bell in OWCS 1941 pl.VI,
but is now untraced. Both versions were
highly praised by the *Athenaeum*'s
reviewer; of this version he wrote 'Mr
Boyce . . . has the art to give not only
absolute truth of aspect to studies of
commonplace themes, but a grandeur
which elevates them to the poetic class of
art. No commonplace painter . . . could
have invested the barn and farmyard in
'Old Barn at Whitchurch', its litter and
its sleek, sable occupants, with so much
of the dignity of a magnificent building,
nor could such a one have given to stable-
litter and black pigs the charm of
admirable colour. The study is a
masterpiece'.

39 The White Swan at Pangbourne 1863–4
Watercolour $11\frac{5}{8} \times 16\frac{1}{16}$ (295 × 422)
Inscribed 'G.P.Boyce 63.64'
lower right
PROV: Purchased from Boyce by
Leonard Roux Valpy; . . .; Adrian
Tilbrook, from whom purchased
by the present owner 1984
EXH: OWCS Summer 1865 (319);
Annual International Exhibition
1871
LIT: *Diaries*, pp.40–1.

Christopher Newall

40 Near the Ouse Burn, Newcastle 1864
Watercolour $6 \times 11\frac{1}{4}$ (152 × 285)
Inscribed 'G.P.Boyce Sep.^t '64'
lower left of centre and on the
verso 'Near the Ouse burn
Newcastle | Sept.26 '64 –
forenoon'
PROV: . . .; Abbott & Holder, from
whom purchased by the present
owner 1972
LIT: *Athenaeum*, 2 December 1865,
p.771

Judy Egerton

41 Landscape at Wotton, Surrey: Autumn 1864–5
Watercolour $9\frac{3}{4} \times 13\frac{3}{4}$ (248 × 349)
Inscribed 'G.P.Boyce . 1864–5'
lower left
PROV: . . .; Mrs Lawder-Eaton, by
whom bequeathed to the Tate
Gallery through the National
Art-Collections Fund 1940
EXH: ? OWCS Winter 1867–8 (386);

Landscape in Britain 1850–1950,
Arts Council, Hayward Gallery
and tour, 1983 (24, repr.)
LIT: *Athenaeum*, 30 November 1867,
p.731; Staley 1973, p.109, pl.56b

Trustees of the Tate Gallery

Boyce painted and exhibited several
views of Wotton. This may be the work
exhibited at the OWCS in the winter of
1867–8 as 'Wotton Woods – Surrey –
November Evening' praised by the
Athenaeum's reviewer as reflecting the
chill of autumn in deep tints . . . a real,
though very sober-looking study, that is
enriched by a world of knowledge'. The
background includes a glimpse of
Wotton House.

COLOUR PLATE 7
42 From the Windmill Hills, Gateshead-on-Tyne 1864–5
Watercolour $11 \times 15\frac{3}{4}$ (280 × 400)
Inscribed 'G.P.Boyce 1864.5'
lower left
PROV: Charles Fairfax Murray, sold
Christie's 30 January 1920 (2)
£8.8.0 bt James Richardson
Holliday, by whom bequeathed
to the Laing Art Gallery 1927
EXH: OWCS Summer 1865 (293); *The
Pre-Raphaelites,* Tate Gallery
1984 (238, repr.)
LIT: Staley 1973, p.109; Grigson 1975,
p.139, pl.100

Laing Art Gallery

As Staley points out, 'the murky city of
Newcastle' is faintly visible in the back-
ground. Boyce also showed a view of
'Newcastle from the Rabbit Banks, Gates-
head-on-Tyne' at the same exhibition
(128, present whereabouts unknown), on

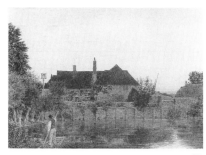

39

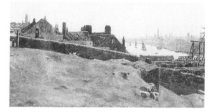

40

41

42

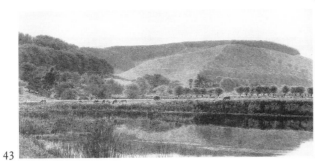

43

44

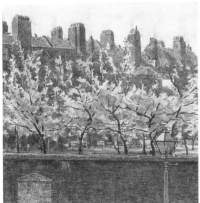

45

which the *Athenaeum* reviewer commented 'a distant view of a manufacturing town interests us in its million lives and fortunes; its subtle colouring seems pathetic, and a glowing sky looks full of prophecy . . .'.

43 **Streatley Hill and the Thames, Sunset** *c.*1865
Watercolour 10⅝ × 21⅞ (270 × 555)
Inscribed as title on label on back of frame
PROV: Boyce sale 1897 (94) £27.6.0 bt Rev. Sir Paget Bowman; Rachel Lawson-Walton, by whom bequeathed to the present owner
EXH: ? OWCS Winter 1866-7 (403 as 'Streatley Hill, Berkshire – Evening')
Mrs Robert Woollcombe

44 **A Home Farm, with a Dovecote and Haystacks** 1866
Watercolour 7⅝ × 9¾ (193 × 248)
Inscribed 'G.P.Boyce Oct 1866' lower left
PROV: Trevelyan family, Wallington Hall, Northumberland
Private collection

45 **Backs of Some Old Houses in Soho** 1866
Watercolour on two pieces of paper joined together
7¾ × 7½ (197 × 190)
Inscribed 'G.P.Boyce April 26 1866' lower centre, and on the verso 'From a 1^st floor of a house overlooking the churchyard of S^t Anne's, Soho | April 26^th 1866'
PROV: Given by Boyce to Rossetti in an exchange of drawings; ? in Rossetti's sale 5-7 July 1882; sold Phillips 3 October 1893 bt C.F.Bell, by whom presented to the British Museum 1942
EXH: OWCS Winter 1866-7 (70); *British Landscape Watercolours 1600-1860,* British Museum 1985 (189, pl.134 in col.)
LIT: *Athenaeum,* 1 December 1866, p.721; *Diaries,* pp.44, 46
Trustees of the British Museum

Painted from the first floor of a house in Prince's St in the spring of 1866. On 21 May 1866 Boyce recorded that Rossetti 'saw and took a fancy to the little watercolour sketch I made in Prince's St., Soho, some weeks ago, and offered a sketch of his for it. I closed, of course'. In exchange, Rossetti gave Boyce 'a little drawing of Miss Wilding's head which I think is a nice view, and which I shall consider yours as makeweight to the exchange for your most beautiful little watercolour' (quoted in Surtees 1971, p.201, no.532).

Reviewing the OWCS exhibition of 1866-7, the *Athenaeum* reviewer wrote that 'Mr. G.P.Boyce . . . finds the secret beauty of a dingy place, such as the Churchyard of St. Anne's, Soho, where a

flash of smoky sunlight on a soot-grimed wall, a line of grimy, old red houses and the struggles of town foliage into verdure, are, with a gas-lamp and a mural gravestone, made by his feeling and skill into a poem and a picture. This speaks to the wise'.

46 Sandpit near Abinger, Surrey 1866-7
Watercolour $7\frac{7}{8} \times 11\frac{1}{8}$ (201 × 282)
Inscribed 'G.P.Boyce 1866.7' lower left and as title on old label on the backing

PROV: L.E.Crawford, sold Christie's 4 May 1914 (28) bt Ethel Oliver; Sir John Trevor Roberts, 2nd Baron Clwyd, by whom given to Mrs A.C.M.Jones, by whom bequeathed to the Walker Art Gallery 1984
EXH: OWCS Summer 1867 (81)
LIT: *Athenaeum*, 11 May 1867, p.629

National Museums and Galleries on Merseyside (Walker Art Gallery)

The *Athenaeum* summed this up as 'a hollow bank of rich orange sand, masses of furze and fern, a fringe of darker woods . . .'

47 The Oxford Arms, Warwick Lane, City of London *c.*1868
Watercolour $14\frac{1}{2} \times 13\frac{1}{2}$ (381 × 342)
unfinished

PROV: . . .; bequeathed by Henry L.

Florence to the Victoria and Albert Museum 1917

Trustees of the Victoria and Albert Museum

Boyce developed typhoid fever in 1868. As he recovered, Rossetti observed that Boyce may have contracted the fever by working in the inn-yard of the Oxford Arms (unpublished letter, The Library, University College London: Ogden MS. 82 p.79).

48 Black Poplars at Pangbourne, Berkshire ?1868
Watercolour $14\frac{1}{2} \times 21$ (367 × 533)
Inscribed 'G.P.Boyce Aug 18[?68]'

PROV: Purchased from Boyce by John Wheeldon Barnes, sold Christie's 7 April 1894 (56) 85 gns bt J.E.Backhouse; . . .; Leger Galleries; Martyn Gregory, from whom purchased by the present owner 1979
EXH: OWCS Summer 1871 (258), priced at 40 gns
LIT: *Athenaeum*, 6 May 1871, p.566; *Diaries*, 1980, p.53

Christopher Newall

The *Athenaeum* reviewer called this 'an eminently characteristic picture, which represents a nearly shadowless effect of daylight, and looks, until we recognize its fidelity, rather flat; yet, when it is studied, it presents a fine examples of solid and vigorous workmanship, with subtle colouring and complete modelling'.

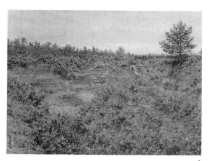

46

47

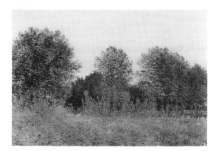

48

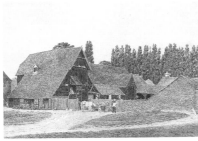

49

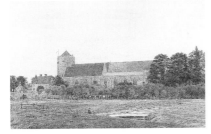

50

51

49 Farm Buildings, Dorchester, Oxfordshire ? 1869
Watercolour 14⅛ × 21⅛ (370 × 535)
Inscribed on the verso
'G.P.Boyce Dorchester
Oxfordshire'
PROV: Boyce sale 1897 (99) £37.16.0 bt
Charles Fairfax Murray, by
whom presented to the
Fitzwilliam Museum 1908
EXH: ? OWCS Summer 1869 (262 as
'Dorchester, Oxfordshire'),
priced at £35
LIT: *Diaries*, p.50
The Syndics of the Fitzwilliam Museum, Cambridge

50 Dorchester Abbey and Meadows, Oxfordshire ? 1869
Watercolour 10¾ × 16½ (273 × 420)
Inscribed
PROV: Boyce sale 1897 (79) £23.2.0 bt
Charles Fairfax Murray, ? on
behalf of the Boyce family; by
descent to the present owner
EXH: ? OWCS Summer 1871 (208),
priced at 30 gns, rather than
OWCS Winter 1877–8 (153,
'Dorchester Church, Oxfordshire
– study for an exhibited drawing')

LIT: *Athenaeum*, 1871, p.566; *Diaries*,
p.53
Madeline Goad

This is probably the work exhibited in
1871 as 'The Abbey Church, Dorchester,
Oxfordshire', of which the *Athenaeum*
reviewer wrote 'the long-roofed, short-
towered church and the simple village
which the artist has so often and so finely
treated, are here again expressed with
fresh spirit and completeness. A stream
is in front, with meadows and trees. In
the breadth and delicate colouring of this
example we see the painter at his best in
English subjects'.

51 Landscape at Stokesay, Shropshire *c.*1870
Watercolour 11⅞ × 17½ (282 × 445)
Inscribed 'Stokesay No.49' on
label on back of frame
PROV: Boyce family, by descent to the
present owner
EXH: OWCS Winter 1872–3 (301,
'Stokesay') priced at £18
LIT: *Diaries*, p.55
Mrs Florence Hutchings

52 An Upland Farm in Berkshire *c.*1870
Watercolour 6⅞ × 16 (175 × 406)
Inscribed 'G.P.Boyce' lower left
and as title on back of frame
PROV: Purchased from Boyce by
H.T.Wells 1871; thence by family
descent to the present owner
EXH: OWCS Summer 1871 (218),
priced at 15 gns; Tate Gallery
1923 (270)

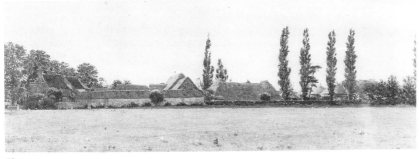

52

LIT: *Athenaeum*, 6 May 1871 p.566; *Diaries*, p.53
Private collection

The *Athenaeum* reviewer described this as showing 'a line of red buildings, with slate roofs and tiles, among trees; in front, a newly-reaped field that is nearly orange in its tint; the trees are admirably drawn, and graceful as plumes. The work is powerful, though singularly sober and delicate in its colour'.

53 Church and Ancient Uninhabited House at Ludlow 1871-2

Watercolour 15½ × 20½ (394 × 521)
Inscribed 'G.P.Boyce . 71-2'
lower right

PROV: Purchased from Boyce by Charles Grainger in 1873 for £55; ? bt back by Boyce; Boyce sale 1897 (106) £17.17.0 bt Matthias Boyce, and thence by descent to the present owner

EXH: OWCS Summer 1873 (90) or Winter 1872-3 (211); *Universal Exhibition* Paris 1878; Tate Gallery 1923 (92)

LIT: *Diaries*, p.57

Michael Harvey

Boyce exhibited numerous Ludlow subjects in the early 1870s. A.G.Street remarked of Boyce 'His subjects are at times frankly, and almost aggressively, unorthodox. In a drawing like that of the church and old houses at Ludlow, the ordinary rules of composition are simply thrown overboard' (OWCS XIX, 1941, p.3)

54 A Street Corner in Ludlow 1872

Watercolour 17¼ × 12¼ (439 × 311)
Inscribed 'G.P.Boyce . 1872'
lower left

PROV: Purchased from Boyce by John Wheeldon Barnes; his sale Christie's 7 April 1894 (52) 11 gns bt Charles Fairfax Murray, ? on behalf of G.P.Boyce; Boyce sale 1897 (116) £42 bt H.R.Boyce; thence by descent to the present owner

EXH: OWCS Summer 1872 (101), priced £35

LIT: *Athenaeum*, 27 April 1872, p.531; *Diaries*, p.54

Michael Harvey

The *Athenaeum* described this as 'a delicious bit of an English midland town dozing in sunlight, brilliant, yet nearly asleep in the lustre of all-pervading day'. The *Art Journal* considered that Boyce's Ludlow views owed a debt to the Dutch School; commenting on 'Old Houses in Ludlow' exhibited the following year, it observed that 'it invites attraction by its peculiarities, which refer immediately to the Dutch school. It may be considered that the artist has been sitting at the feet of Peter Neefs or some similarly-renowned Dutchman' (1873, p.173).

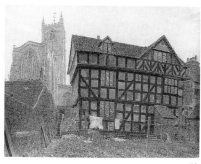

53

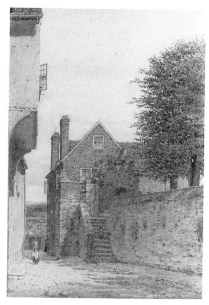

54

55

56

55 At the Back of Great Tangley House, Surrey 1873–83
Watercolour 14¼ × 21 (367 × 533)
Inscribed 'G.P.Boyce 1873 . 83' lower left; numbered '306' on backing

PROV: John Wheeldon Barnes, sold Christie's 7 April 1894 (65) £63 bt W.Flower; G.H.Boyce by 1923; thence by descent to the present owner

EXH: OWCS Summer 1883 (300); Tate Gallery 1923 (306)

Brigadier M.G.Hunt-Davis MBE

56 At Dunster, West Somerset 1874–5
Watercolour 14 × 21¼ (355 × 540)
Inscribed 'G.P.Boyce 74 . 75' across lower right corner, and as title on label on back of frame

PROV: Purchased from Boyce by John Wheeldon Barnes 1875 for £63; his sale, Christie's 7 April 1894 (64) £47.5.0 bt 'Mr Boyce'; by family descent to the present owner

EXH: OWCS Summer 1875 (98); Tate Gallery 1923 (96)

LIT: *Diaries*, p.62

Mrs Florence Hutchings

57 Ancient Tithe-Barn and Farm Buildings near Bradford-on-Avon, Wiltshire 1878
Watercolour 8½ × 21 (216 × 530), paper enlarged on all sides
Inscribed 'G.P.Boyce '78' lower left, and 'Ancient tithe barn and farm buildings near Bradford-on-Avon – North View | painted on the spot in the autumn of 1877' on label on back of frame

PROV: ? John Wheeldon Barnes, sold Christie's 7 April 1894 (47) bt Charles Fairfax Murray £42 ? on behalf of Boyce; purchased from Boyce by the Victoria and Albert Museum for £42 in 1894

EXH: OWCS Summer 1878 (219); *Autumn Exhibition*, Walker Art Gallery 1884 (488); *Irish International Exhibition* 1897 (32 or 469)

Trustees of the Victoria and Albert Museum

Philip Webb wrote to Boyce on 9 April 1894 recalling their joint visit to this tithe-barn, adding 'This drawing I thought to be one of your best pieces of good work – work – in truth – which was always good, and often quite perfect of its kind. You should know that you have left for future generations an historic representation of what the Architects and others had not then destroyed, but will soon do so' (un-published letter, British Library: BM 45354 p.283).

The barn (though not the farm) now belongs to the Department of the Environment, and is open to the public.

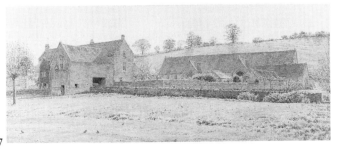

57

58 **The Church and Cours des Tilleuls at Crémien, Dauphiné** ? 1879
Watercolour 16¼ × 11 (412 × 280)
Inscribed 'G.P.Boyce 187[?]9' lower right and as title on label on back of frame

PROV: . . .; Percy Charles Mordan; by family descent to the present owner
EXH: OWCS Summer 1879 (291); Tate Gallery 1923 (305)
LIT: *Athenaeum*, 3 May 1879, p.576

Madeline Goad

COLOUR PLATE 8
59 **Porte Neuve at Vézelay, Burgundy, from Outside the Walls** 1878-9
Watercolour 16½ × 22½ (420 × 576)
Inscribed 'G.P.Boyce . 1878 . 9' lower left, and as title, followed by 'in September 1878' on label on back of frame

PROV: ? Boyce sale 1897 (121) £63 bt Street; by family descent to the present owner
EXH: OWCS Summer 1879 (43); *Autumn Exhibition*, Walker Art Gallery, Liverpool 1884 (539); *Universal Exhibition*, Paris, 1889
LIT: *Athenaeum*, 3 May 1879, p.576

Mrs Florence Hutchings

Reviewing the OWCS Summer Exhibition of 1879, the *Athenaeum*'s art critic noted that 'Mr Boyce has several characteristically "quakerish" pictures on these walls. Let no one miss "The Porte Neuve at Vezelay", an external view of an ancient round tower and its curtain walls, comprising a glimpse through the open gate of a narrow street. The whole is in bright sunlight, seen in the freshest air of spring'.

60 **In the Place du Barle, Vézelay** 1878-85
Watercolour 17⅛ × 12 (435 × 305)
Inscribed 'G.P.Boyce . Vezelay . 1878 . 85' lower left

PROV: . . .; Sir Thomas Barlow, by whom presented to the Whitworth Art Gallery through the Friends of the Whitworth Art Gallery 1944
EXH: OWCS Summer 1886 (34); *British Artists in Europe*, Whitworth Art Gallery, Manchester 1973 (54); *The Pre-Raphaelites and Related Artists*, British Council tour The Hague, Budapest, Bratislava, Prague 1979-80 (1)

Whitworth Art Gallery, University of Manchester

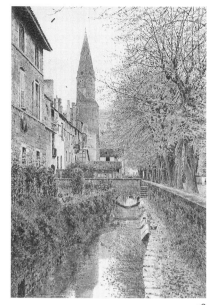

58

59

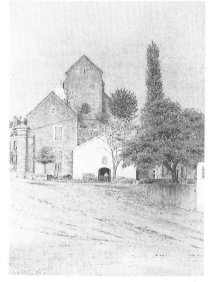

60

61

61 Thorpe, Derbyshire 1879–80
Watercolour $11\frac{1}{4} \times 16\frac{5}{16}$
(285 × 422)
Inscribed 'G.P.Boyce 1879 . 80'
in red lower right
PROV: ? Purchased from Boyce by
Charles Fairfax Murray, by
whom presented to Birmingham
Museum and Art Gallery 1903
EXH: OWCS Summer 1880 (232)
LIT: *Athenaeum*, 1 May 1880, p.573

*Birmingham Museum and Art
Gallery*

The *Athenaeum*'s reviewer of the OWCS
Summer Exhibition of 1880 described this
as 'a picture of sloping meadows, wood-
land, an ivy-clad church tower, a lane
ending in a farm gate and rough hedge.
The whole is suffused by warm grey light,
and the tenderness of the subtly graded
local colouring of the sky, field, and
foliage is exquisite'; but he added (and it
is almost the first breath of criticism that
the *Athenaeum* made of any of Boyce's
work): 'The painting of the gate is rather
thin'.

62

62 In the Auvergne 1880–1
Watercolour $11\frac{7}{8} \times 18$ (300 × 457),
paper enlarged on all sides
Inscribed 'G.P.Boyce 1880.1'
lower left, and with title and
'Light from the left' on labels on
stretcher
PROV: Matthias Boyce; presented by the
Representatives of the late
M.Boyce to the Fitzwilliam
Museum 1917
EXH: OWCS Summer 1881 (193)

*The Syndics of the Fitzwilliam
Museum, Cambridge*

LATE ADDITION

**63 Streatley Mill from Under the
Bridge** ?1859
Watercolour $16\frac{1}{2} \times 21\frac{1}{2}$ (420 × 546)
PROV: Boyce sale (101) £69.6.0 bt
Quilter; . . .; Sir John Trevor
Roberts, 2nd Baron Clwyd
(d.1987)

*The Executors of Sir John Trevor
Roberts, 2nd Baron Clwyd*

For another view of Streatley Mill see
no.24 (repr. on cover).

List of Lenders

Ashmolean Museum 36, 38
Astley Cheetham Art Gallery 10, 12

Birmingham Museum and Art Gallery 61
British Museum 26, 45

Carlisle Museum and Art Gallery 1
Cecil Higgins Art Gallery 35
The Executors of Lord Clwyd 63

Judy Egerton 40

Fitzwilliam Museum 27, 49, 62

Angela Goad 25
Madeline Goad 2, 20, 50, 58
Richard Green 28

Michael Harvey 18, 53, 54
Brigadier M.G. Hunt-Davis, M.B.E. 55
Mrs Florence Hutchings 15, 51, 56, 59
James Hutchings 13
Lewis Hutchings 21

Dr Margaret Jackson 7

Laing Art Gallery 42

Jeremy Maas 4

Christopher Newall 19, 39, 48

Pre-Raphaelite Inc. 5
Private Collection 6, 8, 14, 16, 17, 23, 24, 29, 32, 33, 44, 52, 63

Mr and Mrs Alan Staley 37
G.R. Street 3, 30, 34

Tate Gallery 22, 31, 41

Victoria and Albert Museum 11, 47, 57

Walker Art Gallery 46
Whitworth Art Gallery 60
Williamson Art Gallery and Museum 9
Mrs Robert Woollcombe 43